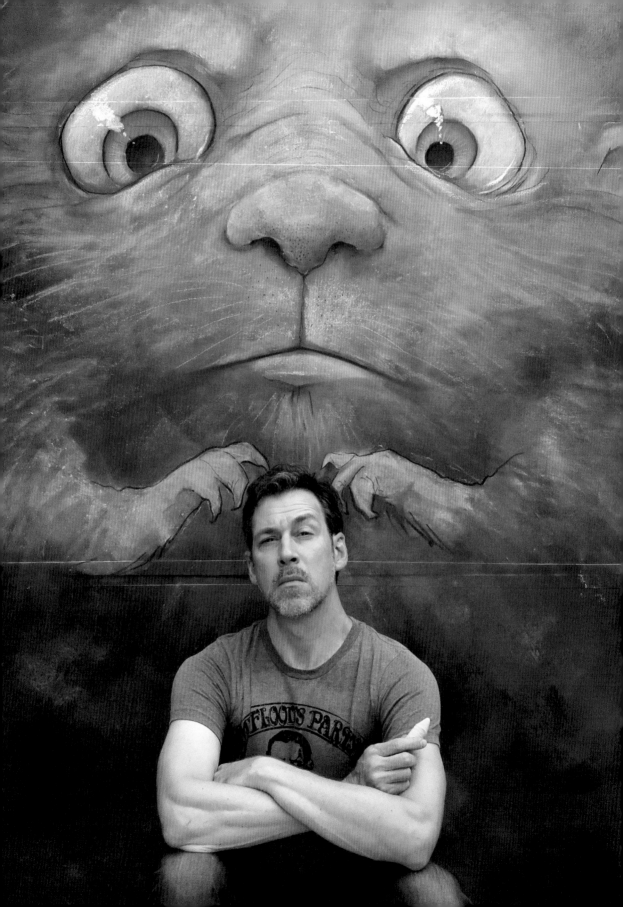

CHANCE ENCOUNTERS

TEMPORARY STREET ART BY DAVID ZINN

PRESTEL

Munich · London ·New York

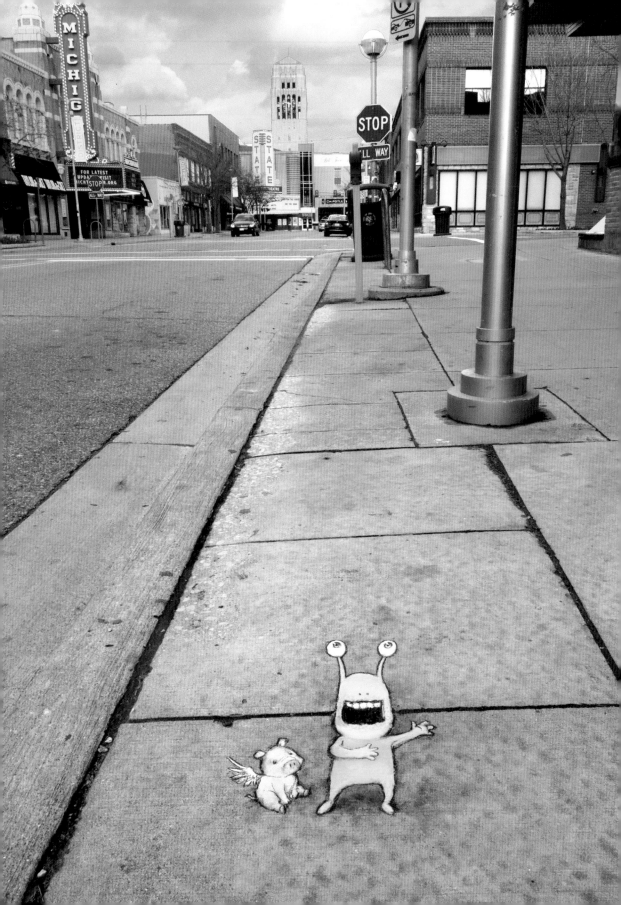

CONTENTS

CHANCE ENCOUNTERS: ON FINDING UPLIFT UNDERFOOT

DAVID ZINN

As a college student at the University of Michigan, I took many long walks around the streets near my dormitory. The neighborhood included a wide variety of young parents and distinguished professors, elementary schools and fraternity houses, wine shops and cemeteries, all jumbled together on tree-lined streets. Strolling through this mishmash felt like flipping randomly though the pages of an entire life's story.

Looking down during one of these walks, I noticed a battered piece of construction paper at my feet. Letters cut from magazines had been pasted onto it like a ransom note, and it spelled out:

> IT's a WoNDERFuL SQuiRRel

This statement was so surprising that I immediately looked around, half-expecting see a squirrel beaming from the grass nearby. I didn't.

Even though this was clearly just some child's lost homework—from what kind of assignment, I can only imagine—I couldn't shake the absurd feeling that it had been left on the street specifically for me to find, and that maybe I should remain on the lookout for a squirrel worthy of its praise. That paper is still hanging in my studio more than thirty years later (see opposite). I don't think I've met the squirrel it refers to, but I have noticed a lot of remarkable ones along the way.

This is just to say that I have good reasons to look at the ground while I walk and a reasonable expectation that doing so will tell me things. That, perhaps more than anything else, has led me down the road to becoming a sidewalk artist.

Aside from finding that note, the primary training I received for my current career started as a diversion my parents employed to keep their two young sons well-behaved in restaurants.

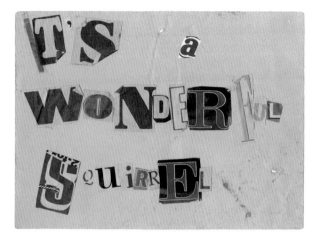

It's a Wonderful Squirrel, c. 1988
Glossy paper, newsprint, candy wrapper, ink
stencil, and glue on construction paper, 9 x 12 in.
Artist unknown

My brother and I didn't fight very often, but when we did, we were loud.
When we didn't fight, we were louder. Luckily, there was one quiet activity
we found irresistible: drawing. I've noticed that this is a nearly universal
trait in the young children I've met, and I think this is because we start
our lives as passengers, carried from place to place and seeing much
but doing very little. The first time we make marks on a surface within our
reach, we discover that we have the ability to leave the world different
than the way we found it, which is understandably empowering. This new
power, coupled with a blissful ignorance of consequences, is probably
why so many of us received our first punishment for drawing on a wall.

My parents clearly knew about this childish fascination and used it as a
secret weapon. Any time my brother and I started to percolate in public,
my father would remove two pages from a blank pad of paper he car-
ried in his shirt pocket and place them in front of his children with a pen
alongside each. Like moths to a flame, we became completely absorbed
in creating our tiny ballpoint masterpieces, and in return my father was
guaranteed peace and quiet so long as his pad of paper didn't run out.

This worked so well that one restaurant hostess who only ever saw the
backs of our heads bent over our work (and couldn't see the paper or the
pens in our hands) confessed years later that she assumed my parents
must have beaten us to get such abject submission from their kids.

I happily engaged in this diversion for more than a year before I noticed
that my elder brother's drawings looked more like the things he was

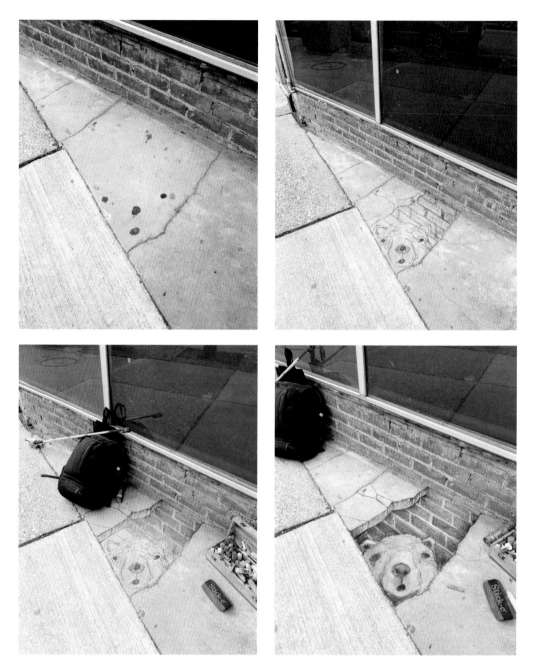

If you stare at the sidewalk long enough, it starts to stare back.

Ann Arbor, Michigan
March 31, 2021

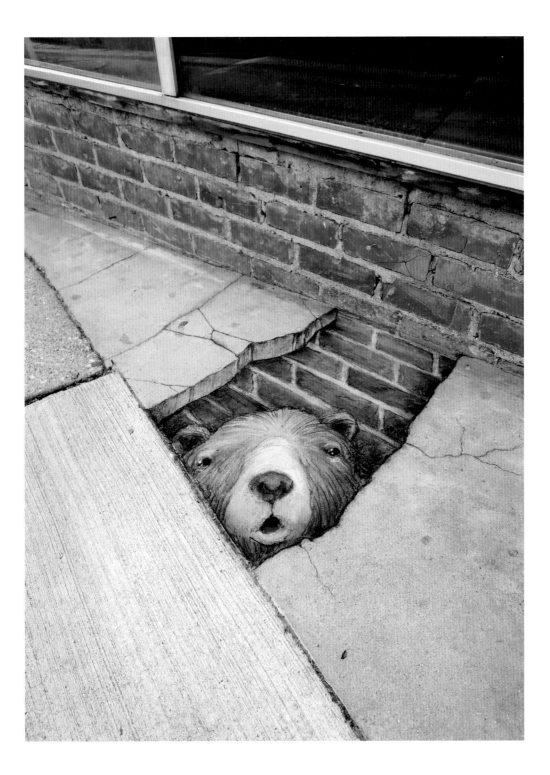

trying to draw than mine did. By comparison, my drawings were wobbly and vague and often needed explanation. Noticing this difference became so frustrating that I started refusing my blank piece of paper entirely, leaving my brother to draw alone and my parents with only 50 percent success in keeping their children quiet.

Looking back, I think this moment of frustration is where many of us lose interest in making art. All children start out as confident artists because young children are confident about everything; that's why they require supervision to avoid being run over in the street. However, an important part of growing up is learning that other people exist and have different thoughts, feelings, and abilities than ourselves, and although that's an essential building block of civilized society, it can create deep insecurities around making art. Instead of gleefully transforming the blankness of all the surfaces around us, we start to wonder whether the marks we make are good enough to exist, and even if no one else criticizes them, we heap disappointment on ourselves for everything that doesn't come out "right." This often leads to a paradox: the infinite opportunities contained in a blank piece of paper become paralyzing instead of inspirational. There's just too much risk that our efforts will turn out badly and we'll ruin a perfect blankness for nothing.

Luckily for me (and for my parents), a new variation on their old scheme emerged. I can't remember who invented it, and I've met a surprisingly large number of people who also played the game and don't remember where it came from either, so the instinct might be as universal as the insecurity it solves.

For this game, each participant begins with a blank piece of paper which they immediately "destroy" with a random scribble. The scribbled papers are then swapped around and each person tries to create something—anything—out of the meaningless chaos they have been given.

In my family this was called the Doodle Battle, yet there was no "battle" in the sense of one person winning or losing (see opposite). We would compare our results and marvel at the unexpected images that emerged, but our battle was not against each other. We were fighting against our own insecurities and the intimidation of the perfect blank page. Making original art on a blank page requires poise and confidence, but creating anything at all out of a scribble is an act of kindness to an otherwise ruined piece of paper.

Two simulated examples of the Doodle Battle created by David Zinn using pencil on copier paper

As it turns out, there is a scientific reason why the Doodle Battle is so easy: our mental habit of pareidolia. Pareidolia is our psychological habit of perceiving patterns in the world around us even when our common sense tells us no such pattern exists. I suspect this dates back to a time when human beings were a more active part of the prey–predator relationship, and so recognizing a camouflaged rabbit or tiger might have made all the difference in eating or being eaten. Over the centuries, this seems to have filtered down into almost every part of our lives, and may well be the psychological soul of art: how else are we able to look at globs of differently colored paint smeared on a canvas and believe we see a face? For us, it will always be easier to fill in the gaps and connect the dots than to make something out of nothing. Luckily, the world is almost entirely composed of the former.

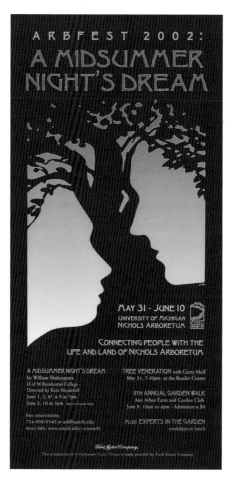

Poster for *Arbfest 2002: A Midsummer Night's Dream* presented by the University of Michigan Residential College and Nichols Arboretum, Ann Arbor, Michigan. Design and illustration © 2002 David Zinn

The Doodle Battle kept me well-behaved in public for the rest of my childhood, but it also protected me from ever considering myself a serious artist. I continued to make silly creatures out of stains on placemats and advertisements on drink coasters, but I was reluctant to create any serious art with more serious tools. In college, I studied creative writing instead of art, presumably planning to fill pages with words and then sneak my drawings into the spaces left over. Too late, I realized that blank pages are just as much of an intimidation for writers as they are for other artists, and I failed to find a scribbling equivalent for language.

After college, I saw no holes in the world that needed to be filled with my writing, but I did find endless opportunities for an experienced doodler. As it turns out, commercial art is largely a matter of connecting dots to solve other people's problems, and this felt so much like the Doodle Battle that I jumped in without stopping to wonder if I was qualified. For two decades, I made myself useful by squeezing my illustrations between recycling instructions and designing posters to advertise *A Midsummer Night's Dream* without using faeries (see above). Sometimes the inspirational scribble was literal and more often it was figurative, but there was always some kind of mess for my inner child to play with.

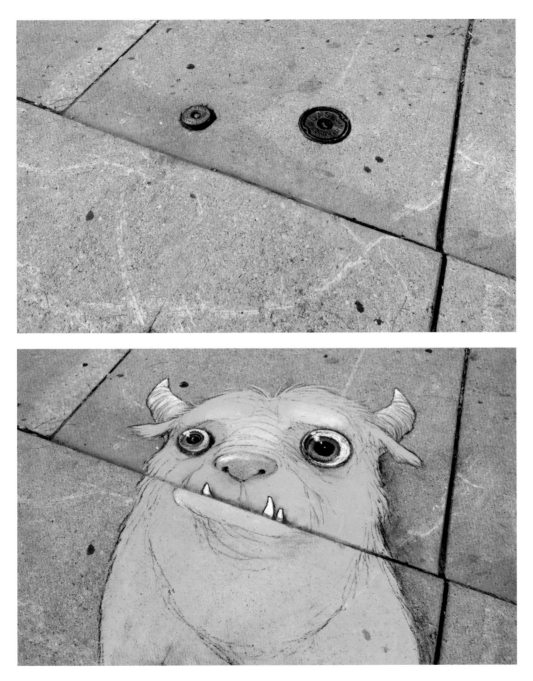

Missing Both the Tricks and the Treats

Ann Arbor, Michigan
October 24, 2020

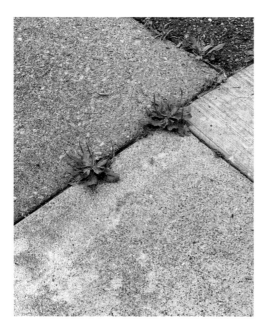

Sluggo and the Art of Wearable Weeds

Ann Arbor, Michigan
July 17, 2020

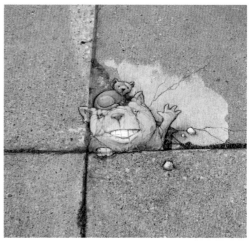

**Underground Greetings from
Cathat McGinty**

Ann Arbor, Michigan
August 25, 2020

I worked as a freelance commercial artist for twenty years, and would probably still be doing that job today if it weren't for the fickle climate of Ann Arbor. For some geographical, meteorological, or metaphysical reason, my home town experiences a dizzying diversity of weather: steaming hot gray days, bright frozen ones, snow, rain, thunder, hail, all shuffled together with a handful of perfect blue skies that could make you weep.

While I was working from home as a freelance artist, my drawing table was set up where I could see exactly what kind of weather I was missing. This view was a selfish joy on days when my neighbors were driving off to their jobs through rain, fog, or seven inches of snow, but when Michigan's rare mild sunny days came along, I struggled to ignore them, knowing that the very next day might be cold and damp or broiling hot—both of which are more appropriate conditions for working indoors.

Self-employed people face an unusual struggle: a traditional boss knows when to discipline or indulge their employees, but this choice becomes more complicated when you're on both ends of each decision. Finally, on a perfect day in June, I rationalized that I could forgivably leave my desk and loiter outside, but only if I was also making art out-doors. This was a shameless procrastinatory excuse, but not a com-pletely irrational one for a professional doodler. I grabbed some chalk and ran out to the sidewalk, thinking I would blow off some steam in the sunshine and then everything would go back to normal.

As it turns out, I failed to anticipate many of the seductive benefits of drawing on the street. The composition and imperfections of a slab of concrete result in a multitude of specks, streaks, and cracks that are a perfect playground for the imagination. Every paved surface is a Doodle Battle waiting to happen, and it's always my turn to draw. In addition to all the inspirational bollards, utility covers, and other functional compo-nents of the urban environment, I have developed a strange fondness for signs of carelessness and decay: cracked pavements and the tufts of grass that grow through them, old pieces of chewing gum flattened into Rorschach blots, and extravagantly failed attempts to patch holes in the street. It's all fuel for pareidolic visions waiting to be embellished by my inner child.

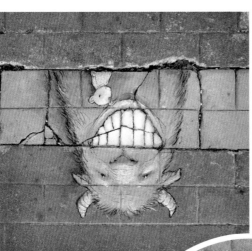

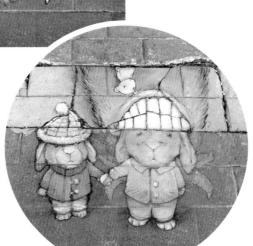

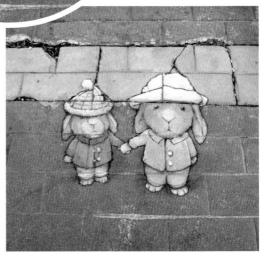

Hatrabbits

Ann Arbor, Michigan
November 19, 2020

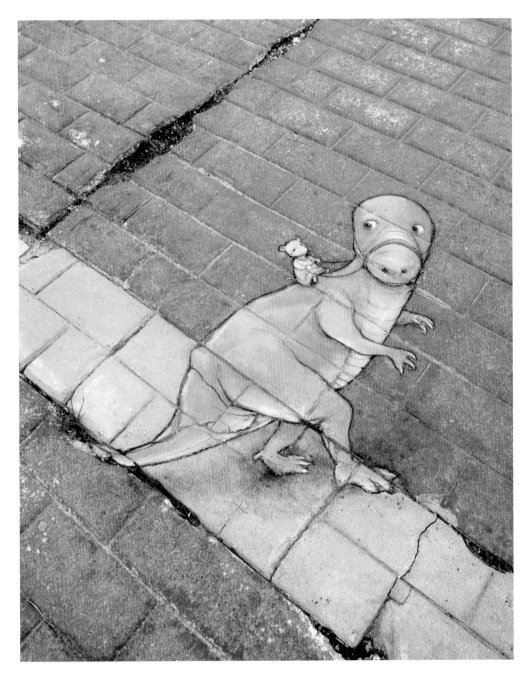

Nadine and the Prehistoric Steed

Ann Arbor, Michigan
May 25, 2021

The other benefit of drawing with chalk on the street is one that count-less people have presumed to be its biggest flaw: you can't keep what you've made. There are a few tricks that can extend the life of a chalk drawing, but fading and smudging are so inevitable that it's honestly easier to just let it go. This embrace of ephemerality shares some phil-osophical ground with the mandala sand art of Tibetan monks, except that mandalas are a far more serious tradition and are destroyed by the monks themselves. Personally, I think the most accurate symbol of our transitory existence is to let your hard work be destroyed by rain or a toddler.

In a practical sense, ephemerality removes many of the distractions that accompany the creation of more permanent art. Drawing with chalk on the sidewalks of Ann Arbor does not require a special permit or permis-sion, so I can create my imaginary friends on a whim with no prepara-tions whatsoever. And since I can't take the results home, I never have to consider whether they are good enough to keep. With both past and future eliminated, my drawings and I are free to focus on our brief shared experience in the present.

In some cases, trying to make these installations permanent would be not just distracting but nonsensical; if an artwork incorporates a fallen leaf or a flower, what would be the point in having the art persevere after its natural components have disappeared?

Not only are there countless opportunities to create spontaneous art out on the street, but each location can be viewed from several different angles, which is another reason to be grateful for transient art. In the past two years, the same cracked section of brickwork in front of the Ann Arbor post office has inspired the toothy smile of a monster, a hat on a rabbit, and the back end of a dinosaur (see pages 16–17). If any one of those drawings had been permanent, the other two would never have existed—and I would be in trouble with the U.S. Postal Service.

I now create art on the street with so little planning and so few conse-quences that it's become as casual an activity as going to the post office or the grocery store. In fact, a third of the images in this book probably happened while I was on my way to do one of those things. I am optimistic that the same incidental relationship applies to those who see my work on the street. With some exceptions, my original chalk drawings are wit-nessed by a few dozen people at the most—not just because the chalk dust washes away so quickly, but because so many people don't notice it while it's there. I don't see this as a problem. On the contrary, it's the comparative invisibility of each underfoot creature that makes connect-ing with them feel so extraordinary, both for me and (I hope) the small audience that finds them after I've walked away. Even though I've never met most of these people, we share membership in an exclusive if acci-dental club, and after the artwork disappears in the rain, that club will never get any larger.

My ideal outcome is that someone might stumble across one of my underfoot creations and be pleasantly baffled about what they're see-ing; they might even believe for a moment that it's a message put there specifically for them to find. If I can get enough people to look at the ground that way, maybe one of us will eventually find that wonderful squirrel.

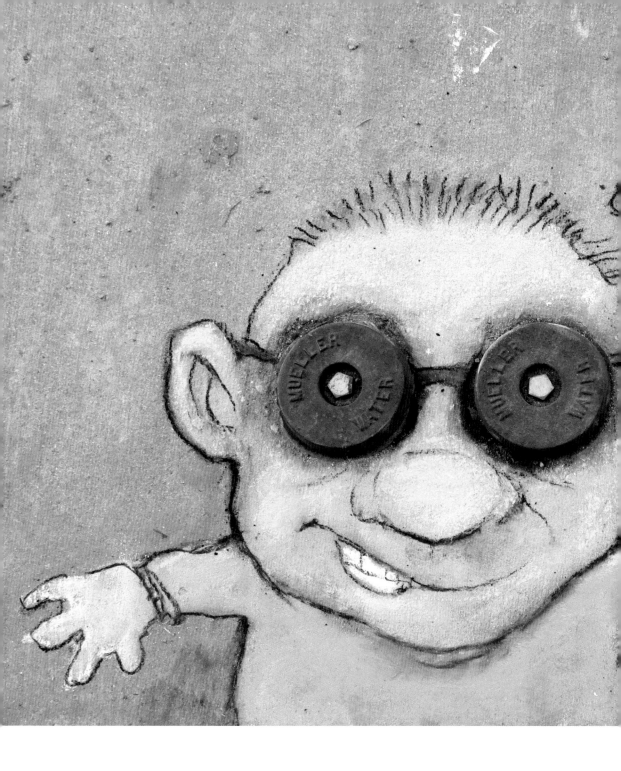

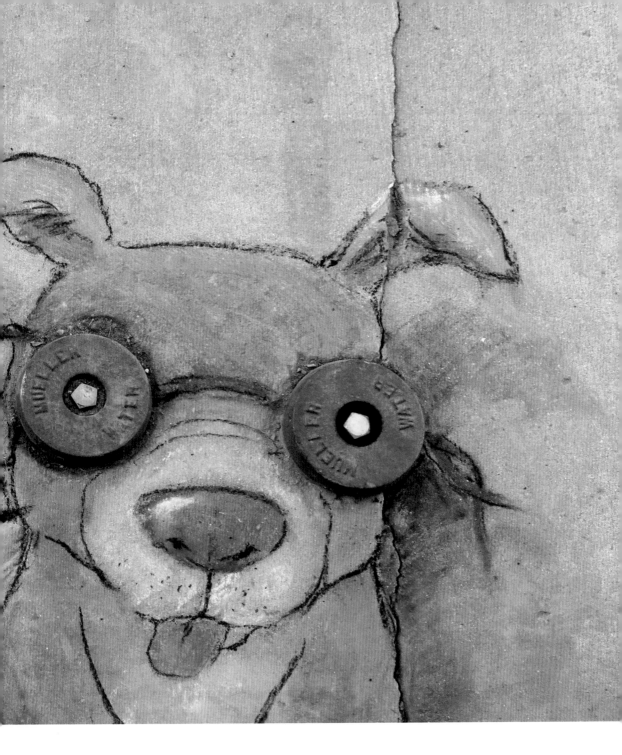

SMALL CREATURES WITH SHORT TALES

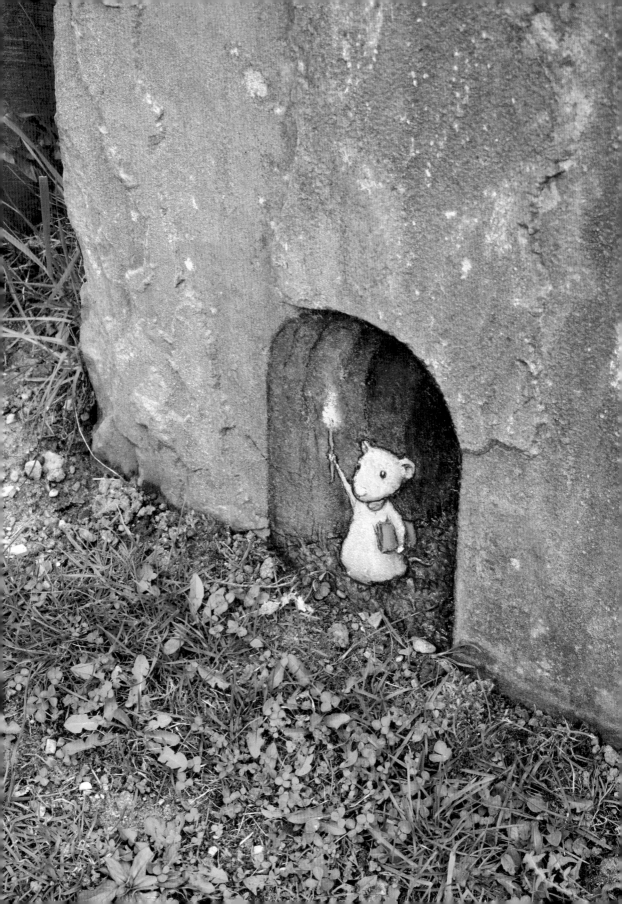

NADINE,

THE MOUSE OF ADVENTURE

Nadine and the Tunnel's End

Ann Arbor, Michigan
April 19, 2021

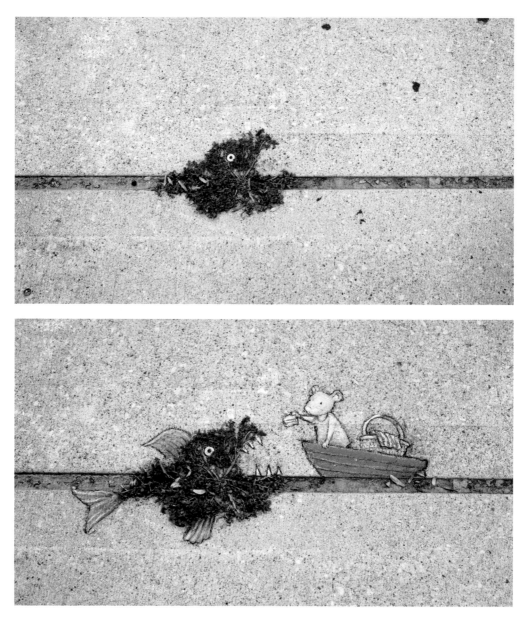

Nadine and the Nautical Picnic
Ann Arbor, Michigan
August 4, 2020

\longrightarrow

Nadine Listens to the Grapevine
Columbus, Indiana
July 30, 2021

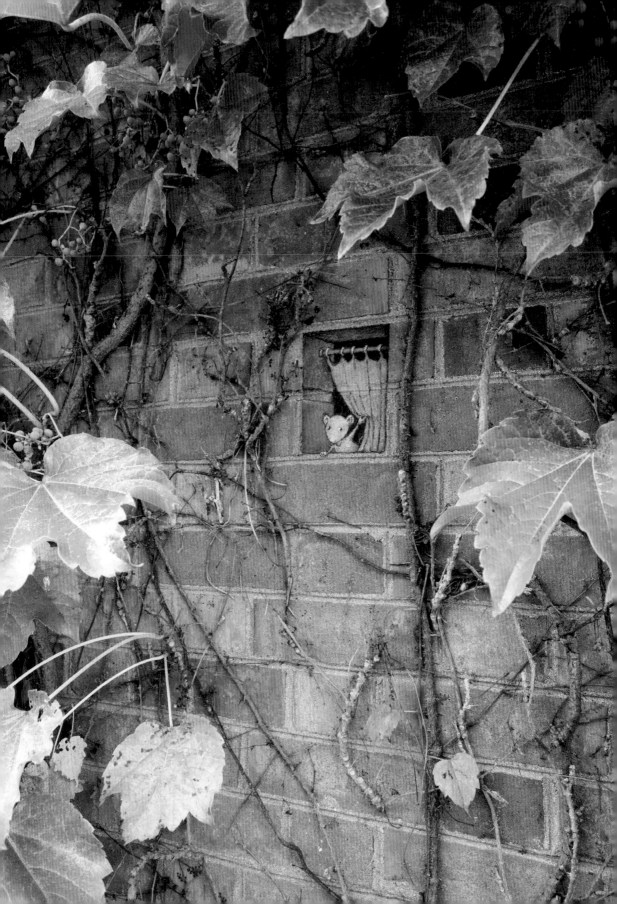

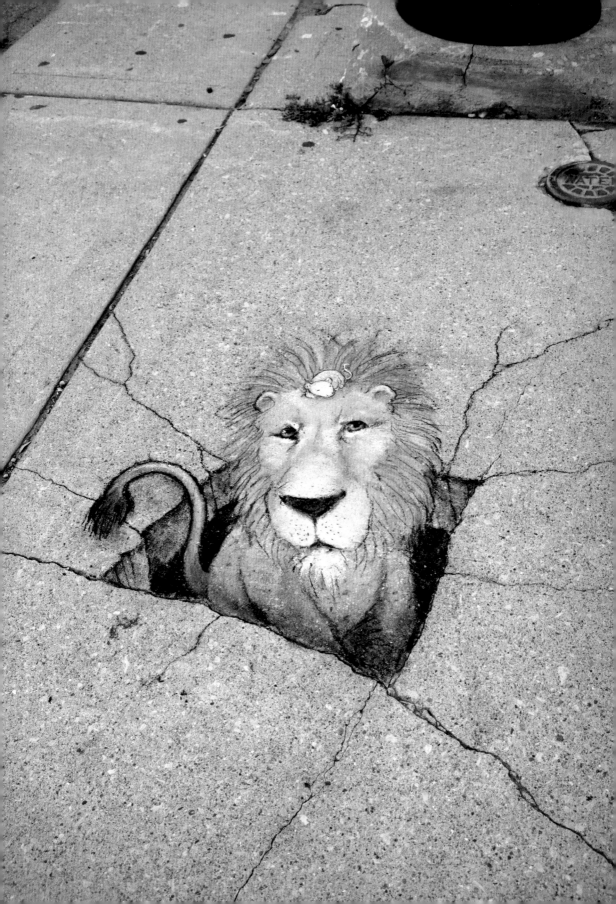

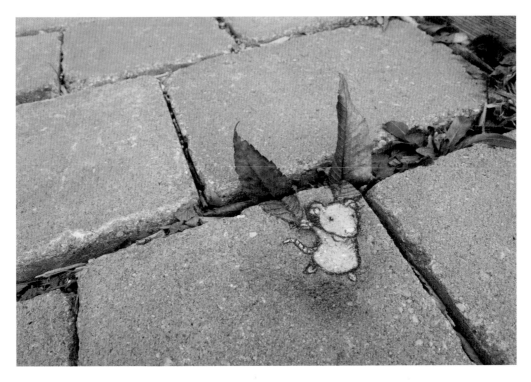

Nadine and the Improvised Wings

Ann Arbor, Michigan
March 8, 2021

←

Nadine's Undisturbed Nap

Ann Arbor, Michigan
September 22, 2020

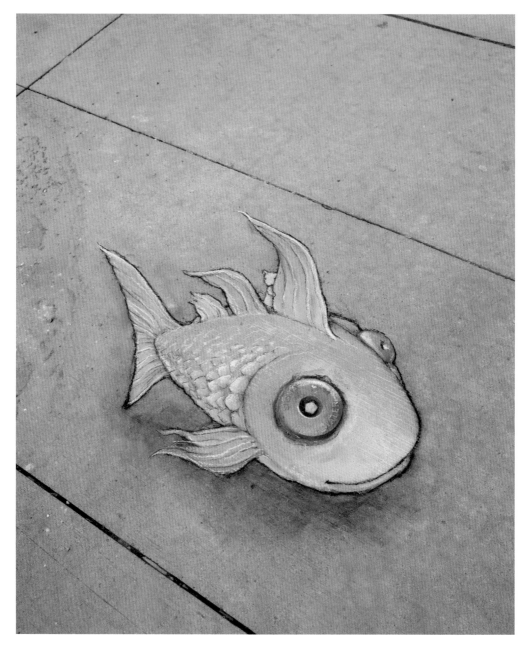

Nadine and the Piscibus

Ann Arbor, Michigan
March 10, 2021

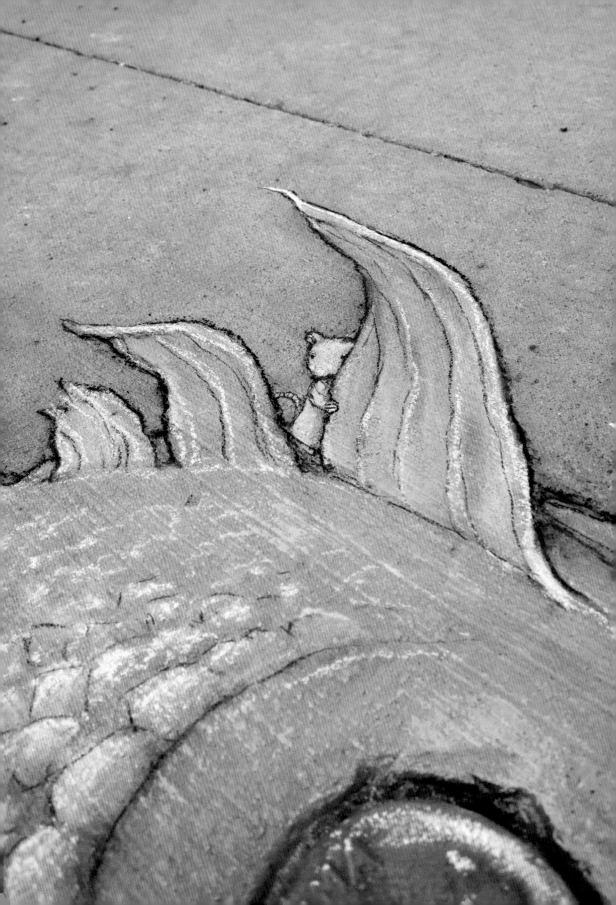

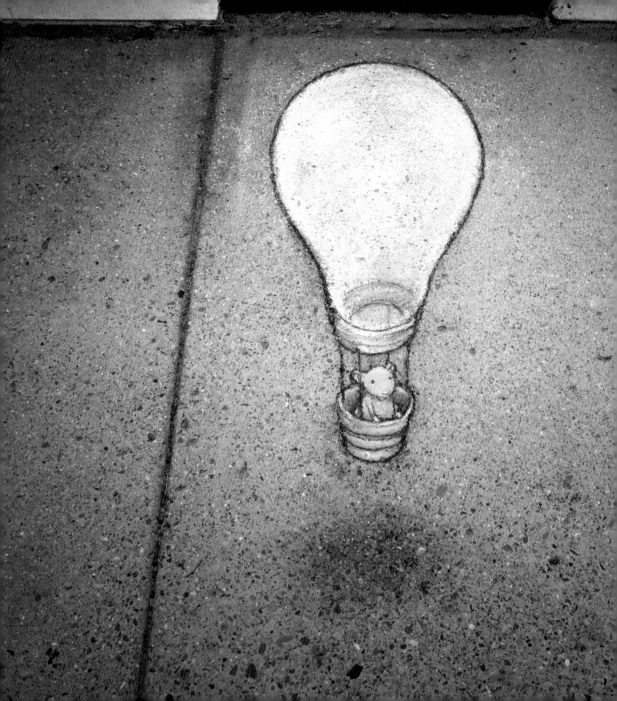

Nadine's Uplifting Idea

Ann Arbor, Michigan
September 8, 2020

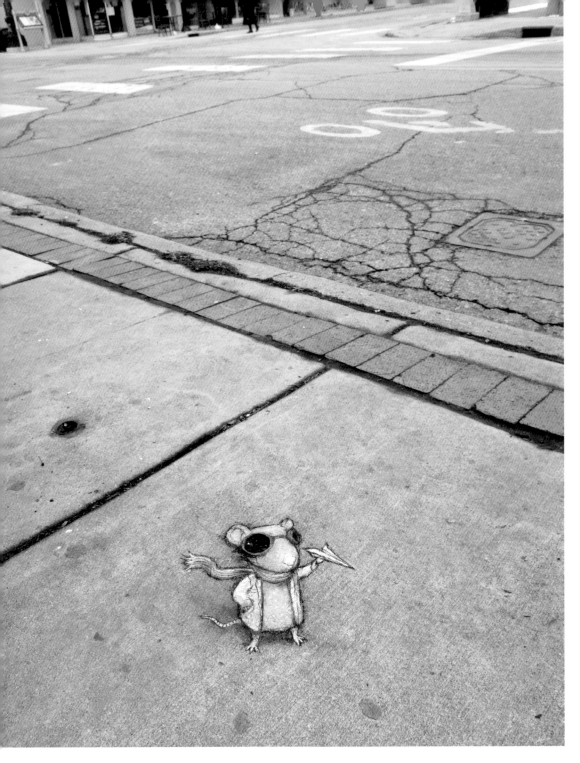

Nadine and the Preflight Calculations

Ann Arbor, Michigan
January 21, 2021

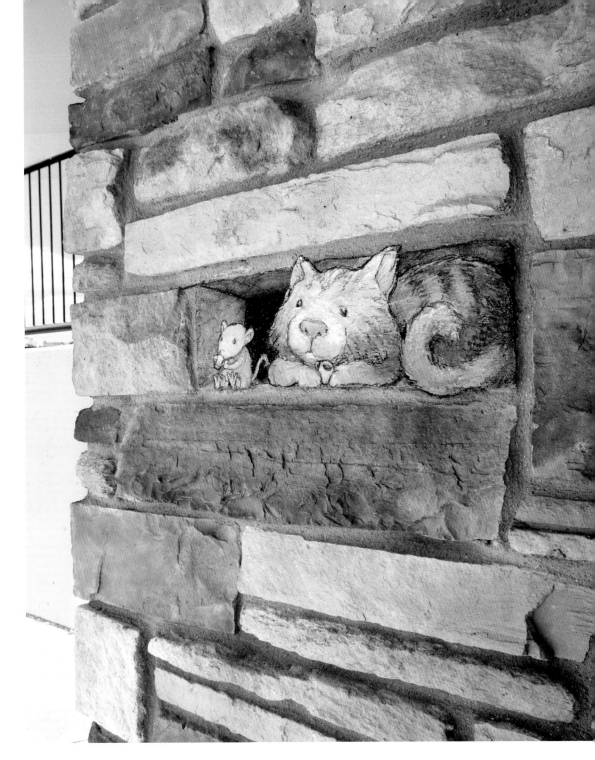

Nadine's Tea Truce

Brighton, Michigan
September 17, 2020

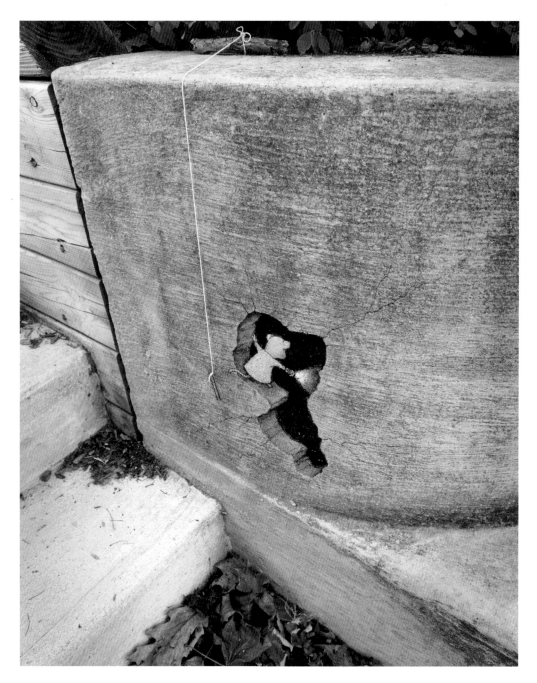

Nadine and the Unexplored Abyss

Ann Arbor, Michigan
August 13, 2020

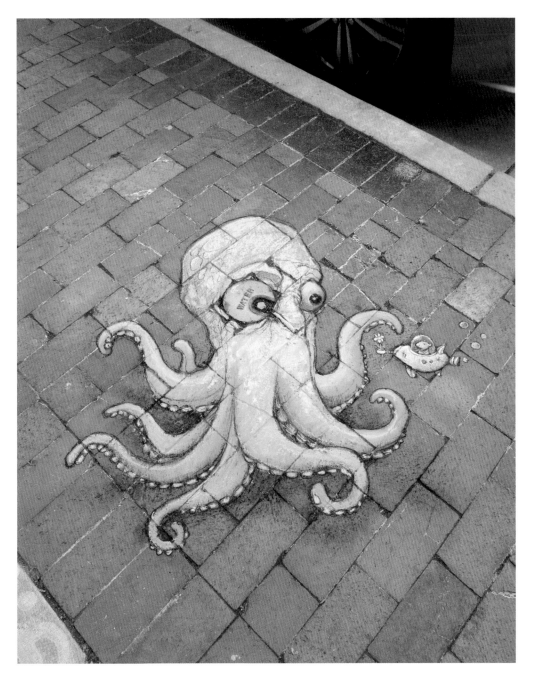

Nadine and the Cephalapology

Ann Arbor, Michigan
May 8, 2021

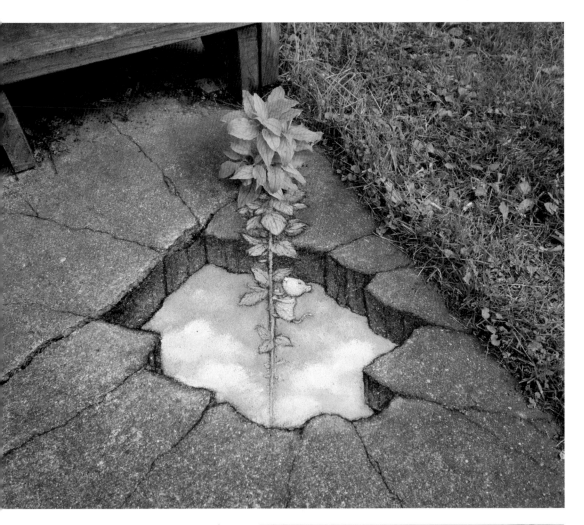

Nadine's Vertical Commute

Ann Arbor, Michigan
June 6, 2021

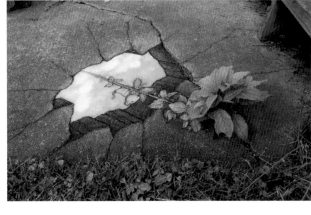

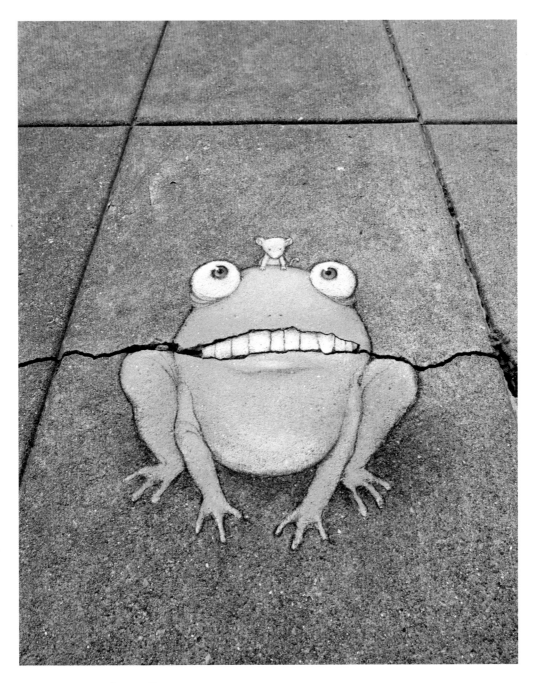

Nadine Hypnotizes a Frog

Ann Arbor, Michigan
August 17, 2020

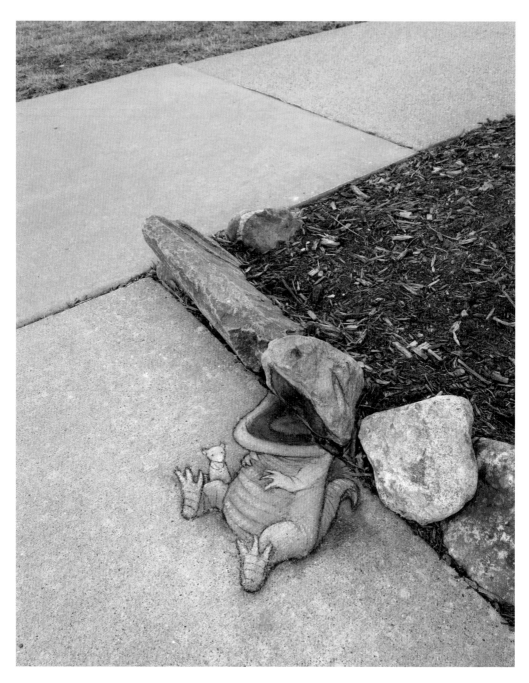

Nadine and the Surprisingly Effective Joke

Ann Arbor, Michigan
March 14, 2021

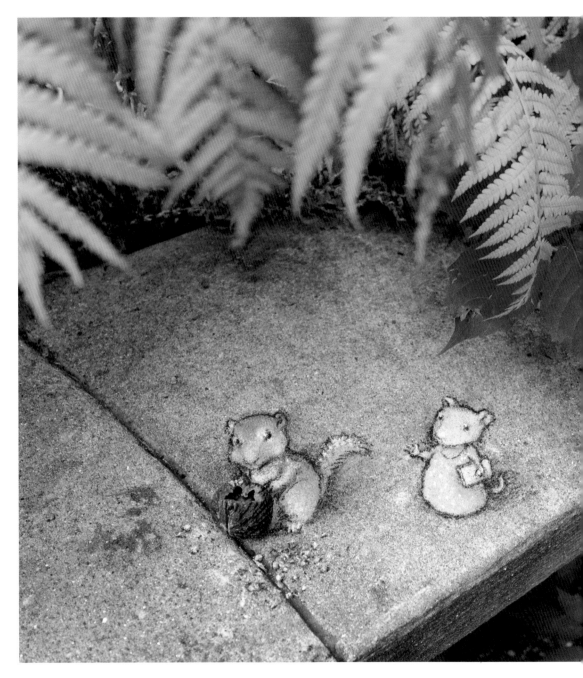

Nadine and the Interrupted Feast

Ann Arbor, Michigan
August 22, 2020

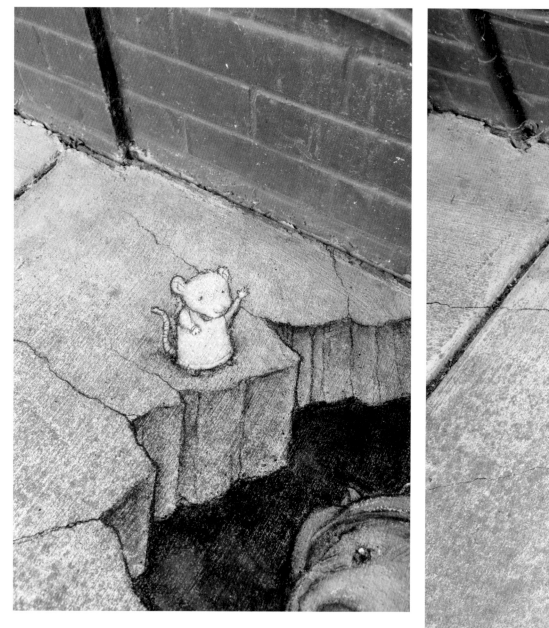

Nadine Meets the Audiophile Wombat

Ann Arbor, Michigan
July 26, 2020

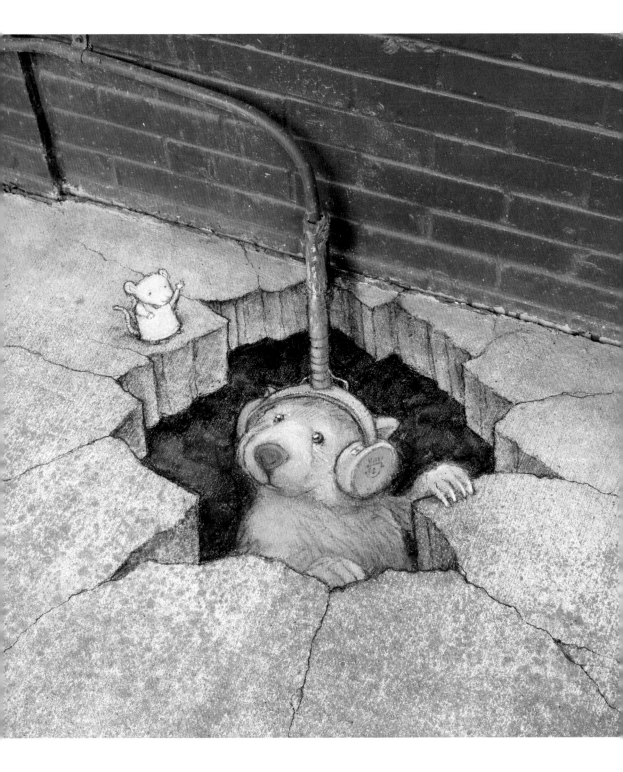

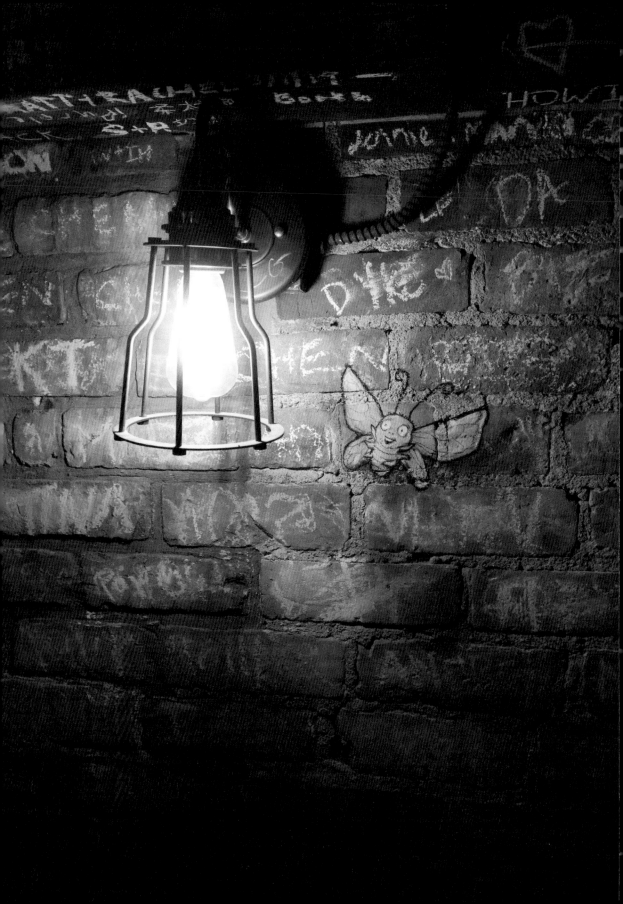

HIDING
IN PLAIN SIGHT

Lamped

Ann Arbor, Michigan
February 28, 2019

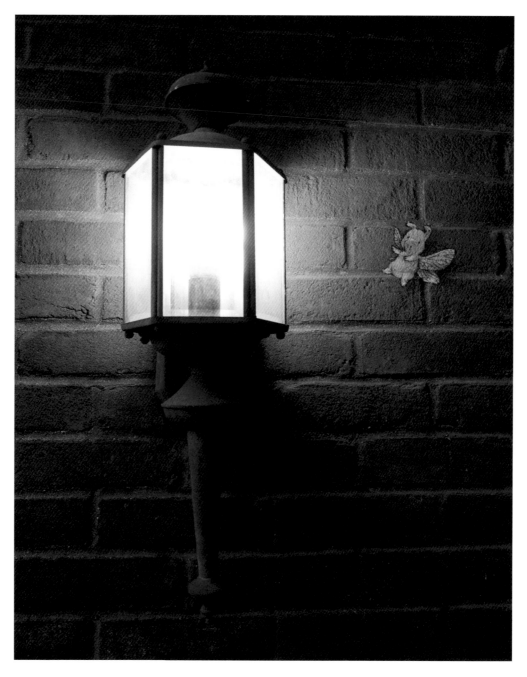

Fly-By-Night Impossibility

Columbus, Indiana
August 1, 2021

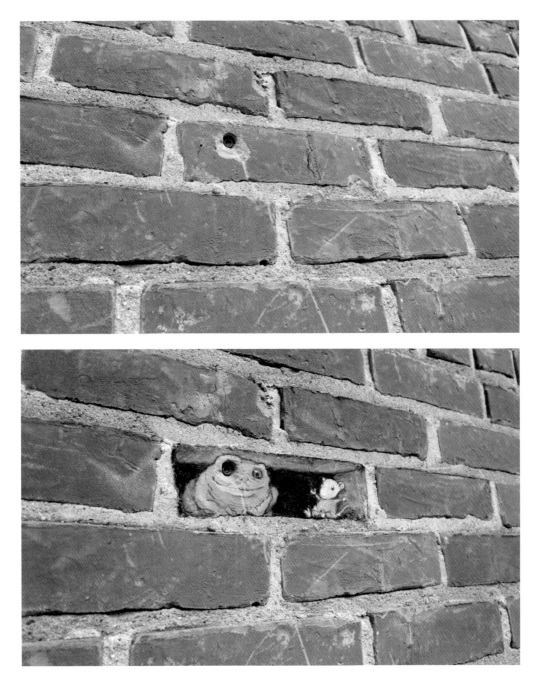

Nadine and the Good Listener

Ann Arbor, Michigan
October 10, 2020

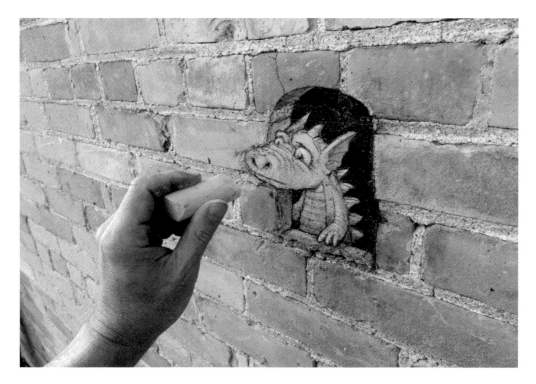

Get out there and show them what they're made of!

Ann Arbor, Michigan
September 25, 2019

→

**Surprise birthday party,
introvert style**

Ann Arbor, Michigan
July 11, 2020

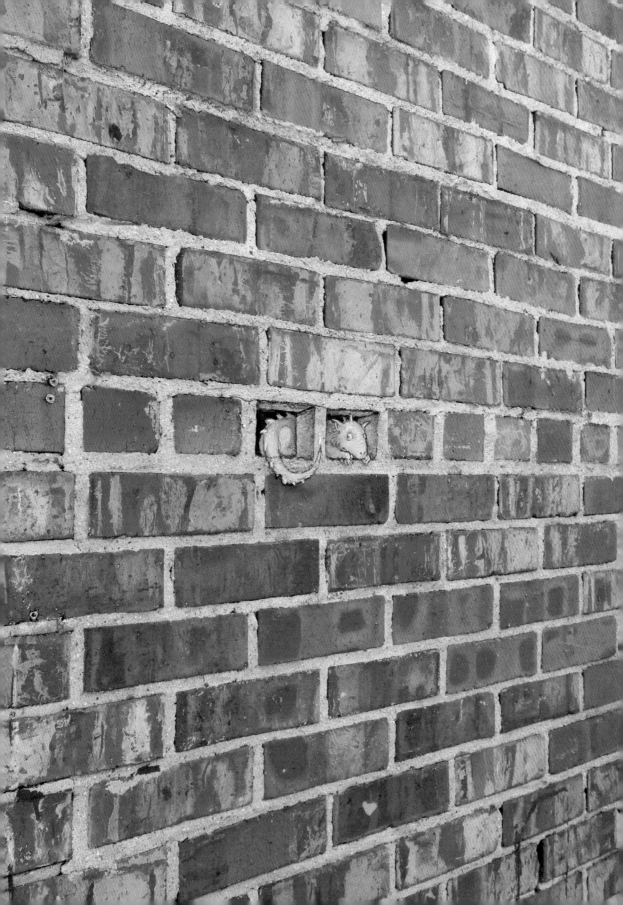

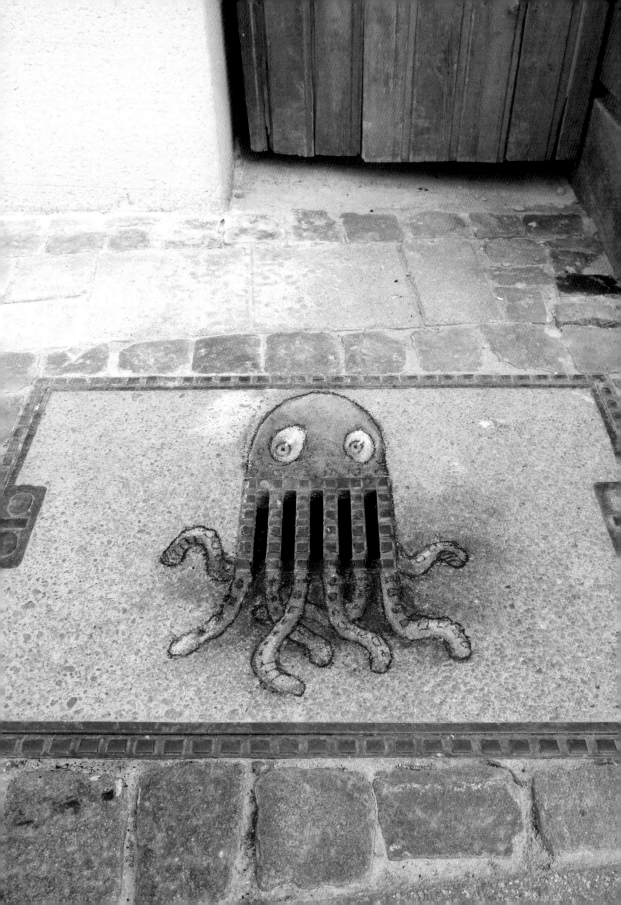

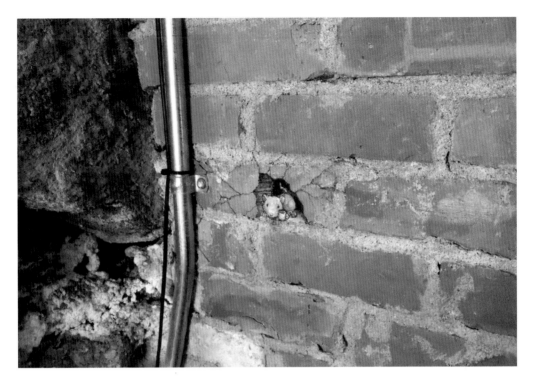

Coffeehouse Mouse
Kate would scurry less if she didn't
live in the walls of a coffee shop.

Ann Arbor, Michigan
February 19, 2019

←

Cora is insecure about her legs,
but she has a grate smile.

Fürth, Germany
May 26, 2019

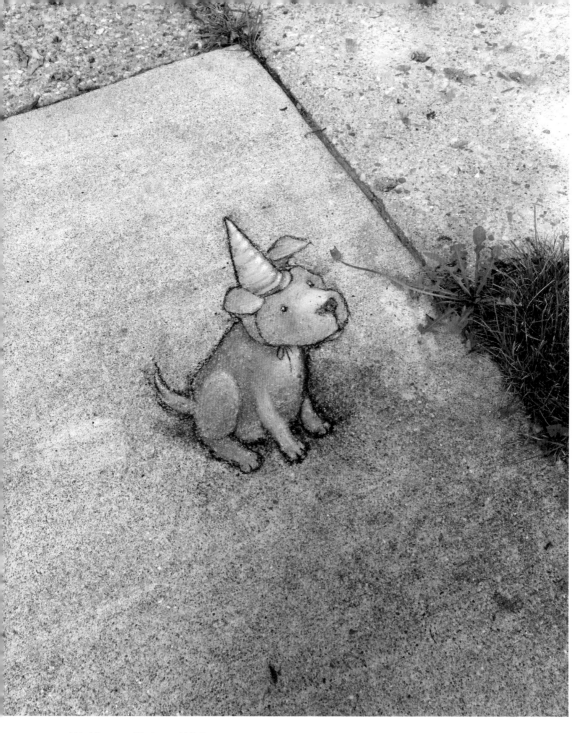

Waiting to Make a Wish

Ypsilanti, Michigan
July 6, 2020

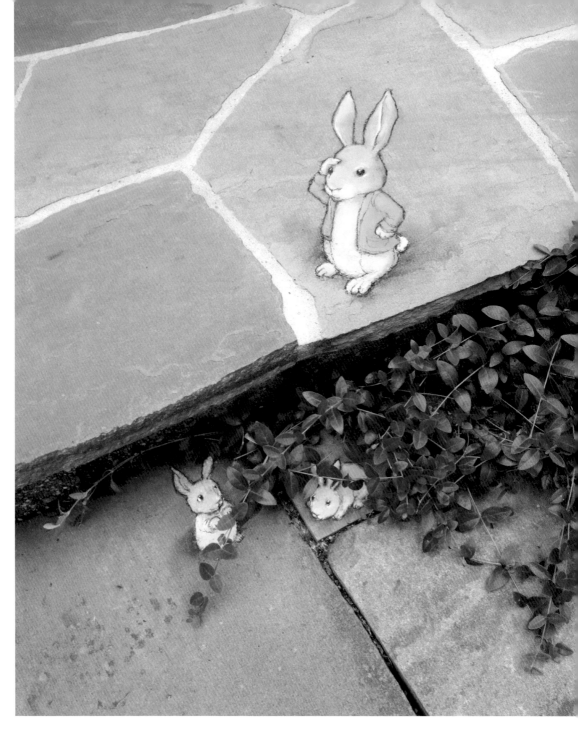

Robert slowly realized he had under-emphasized "seen"
and over-emphasized "not heard" in his parenting technique.

Ann Arbor, Michigan
June 19, 2020

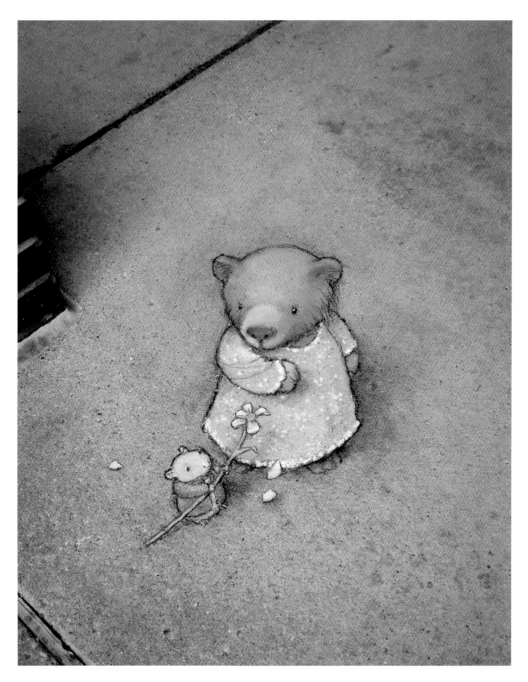

The Courtship

Ann Arbor, Michigan
May 19, 2020

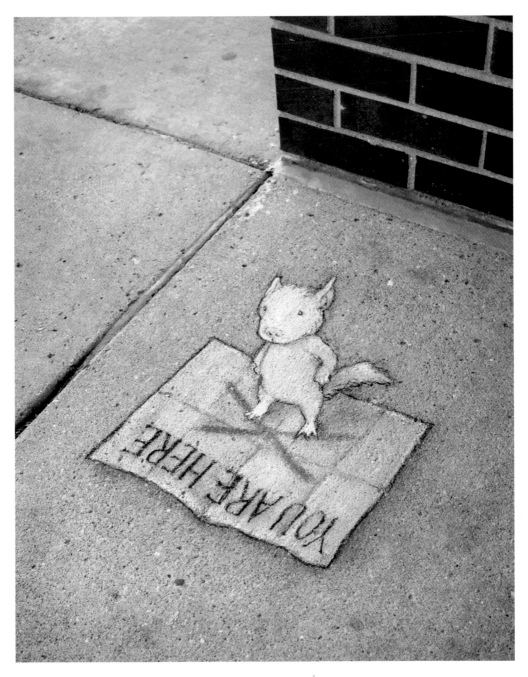

Lucy's map is short on detail but relentlessly accurate.

Ann Arbor, Michigan
May 7, 2020

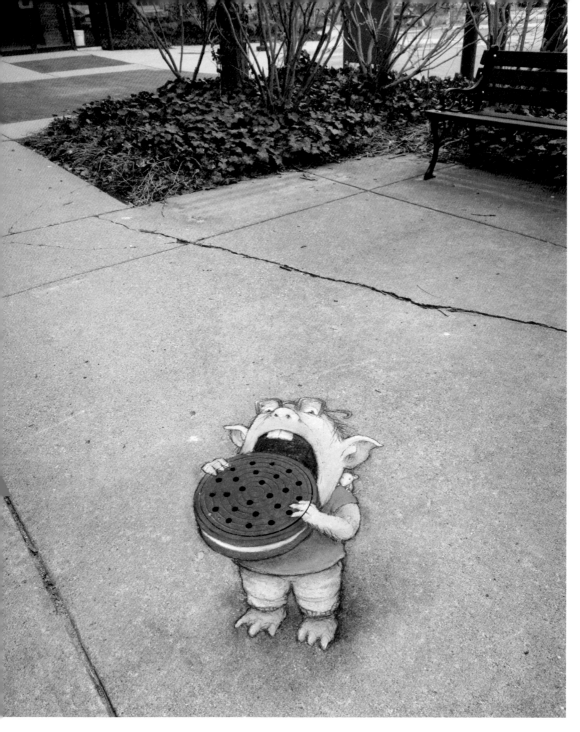

Neil's "one cookie per day" rule has hit some technical snags.

Ann Arbor, Michigan
April 28, 2020

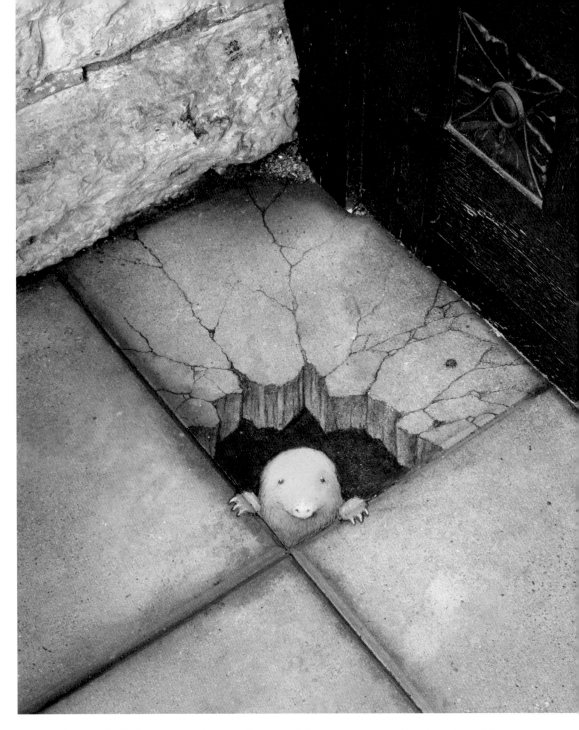

Lily can't decide if she's an understood overachiever or an overstood underachiever, but either way, she's making a lot of progress.

Columbus, Indiana
July 30, 2021

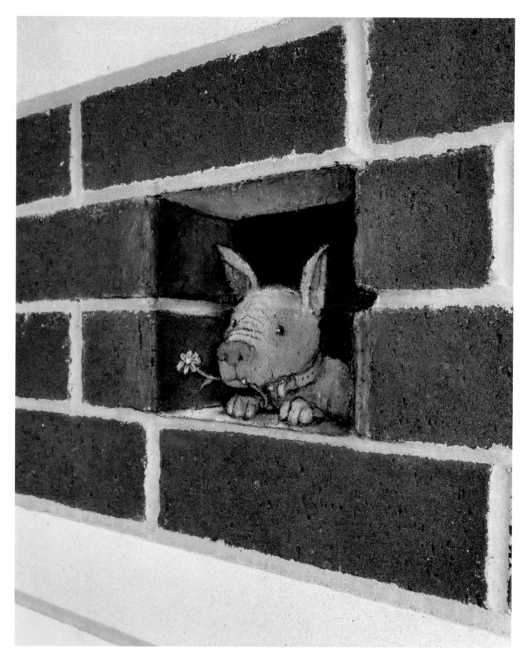

Rosie has an excellent sense of smell, which is why she always carries an olfactory support flower.

Ann Arbor, Michigan
July 14, 2021

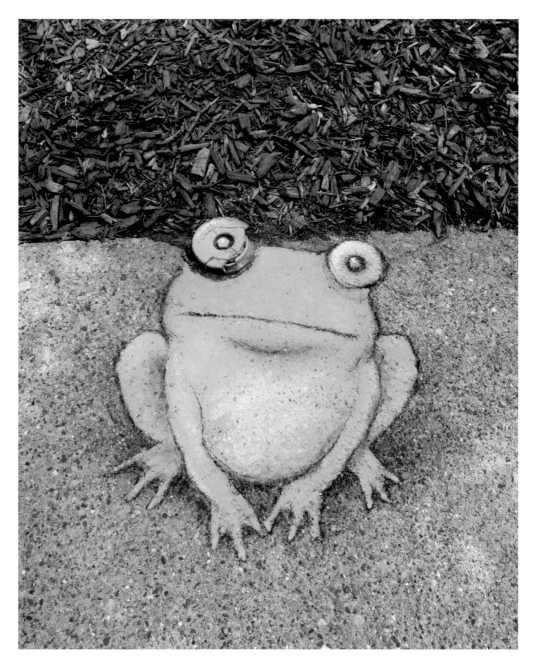

Marv learned this look from the puppy next door;
he's hoping your pocket is full of flies.

Ann Arbor, Michigan
July 9, 2021

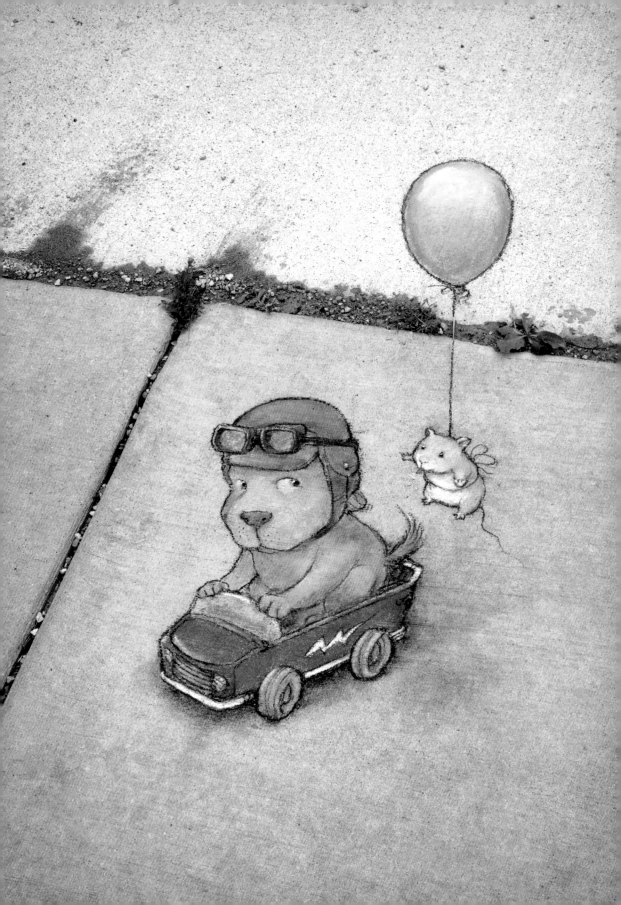

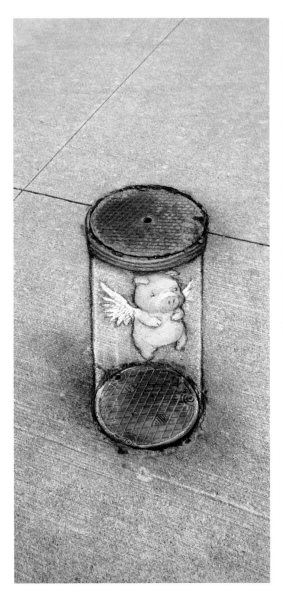

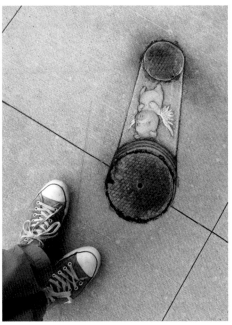

In case of realistic expectations,
break glass.

Ann Arbor, Michigan
June 13, 2021

Val almost immediately regretted choosing the
deluxe "realistic engine sounds" option.

Ann Arbor, Michigan
June 29, 2021

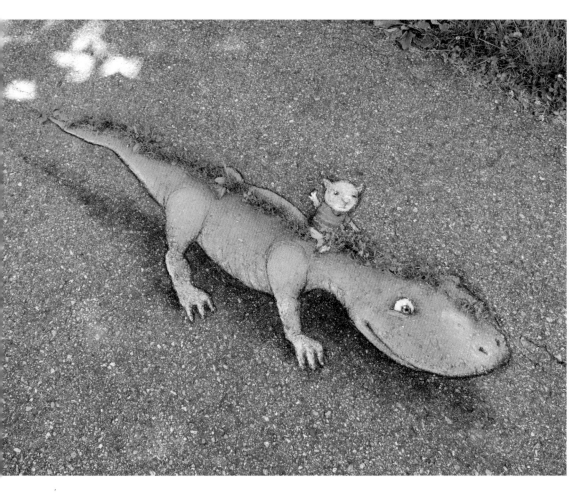

Always choose a vehicle with well-upholstered
seats and a positive attitude.

Ann Arbor, Michigan
June 13, 2021

→

Nadine and the Silent Standoff

Ann Arbor, Michigan
July 17, 2021

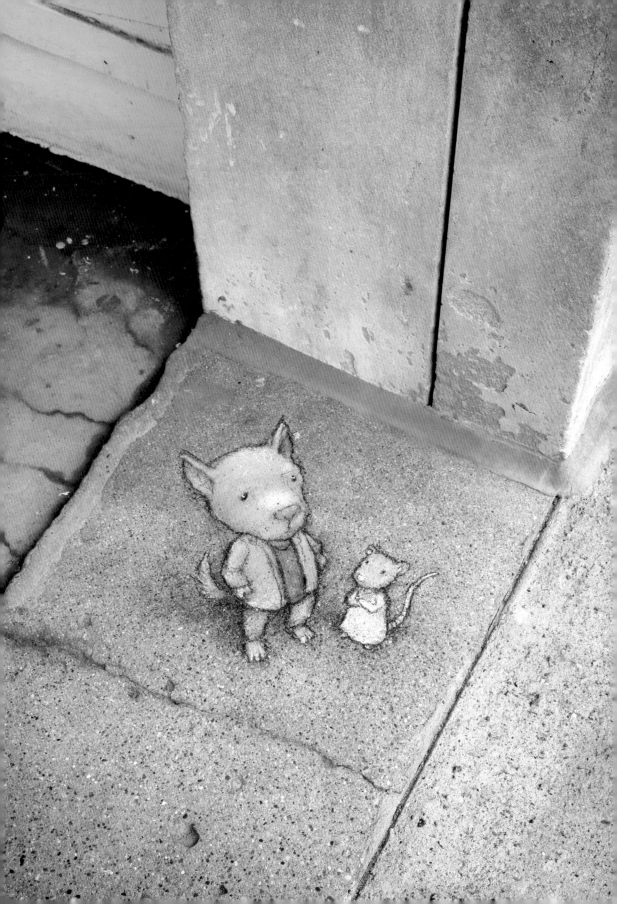

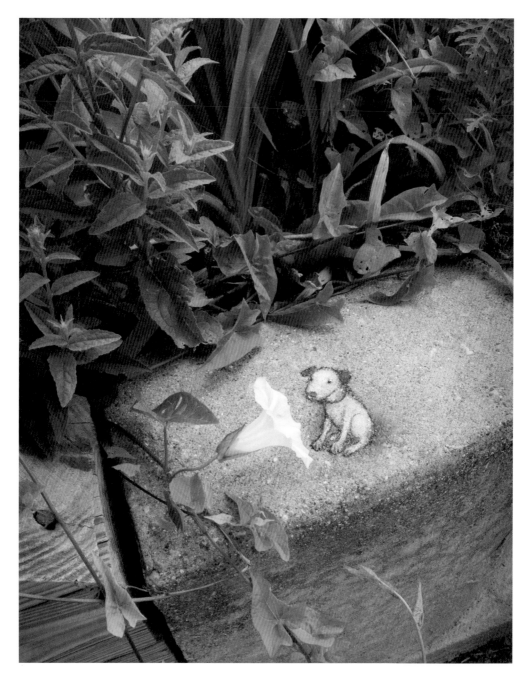

His Mistress's Voice

Ann Arbor, Michigan
June 20, 2021

Marcus slowly realized that there would be no intermission.

Ann Arbor, Michigan
May 31, 2021

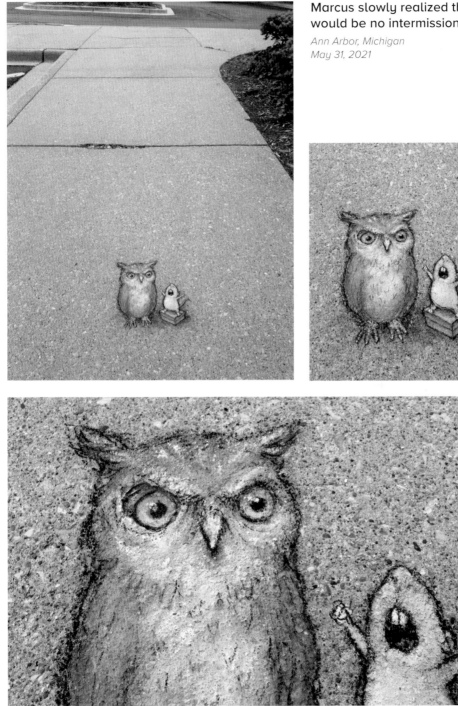

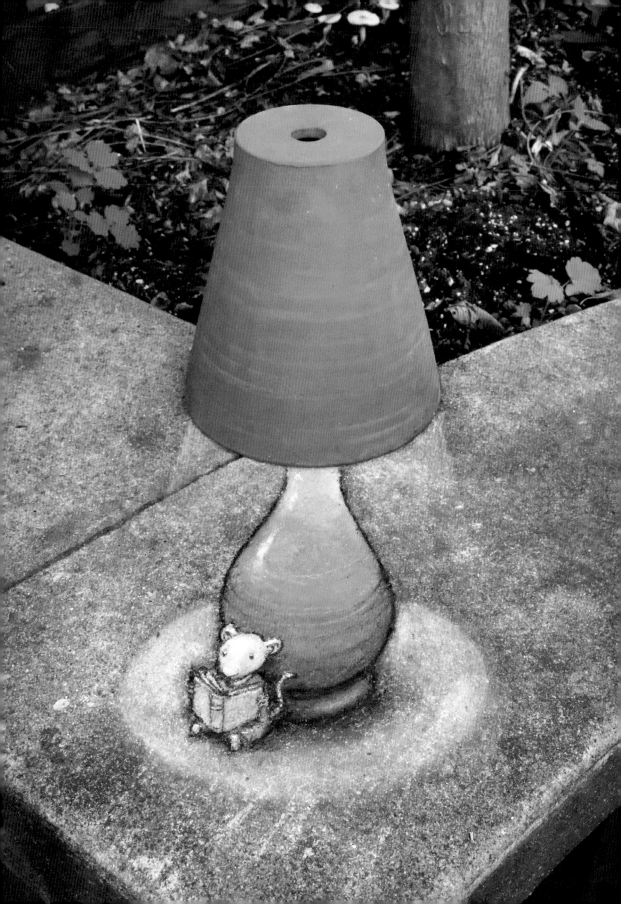

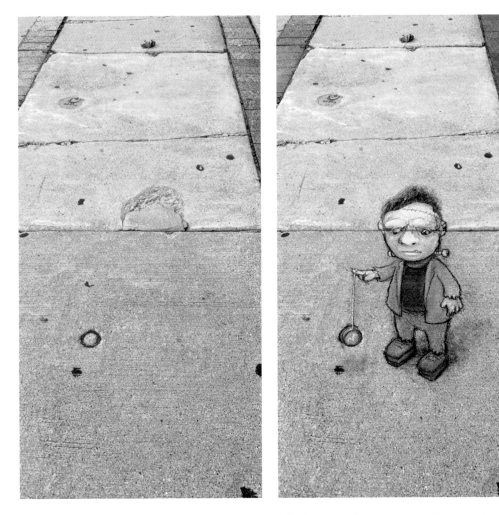

Life lessons from augmented pareidolia:
the first yo is given, but the second yo is earned.

Ann Arbor, Michigan
July 20, 2021

←

An Evening of Adventure

Ann Arbor, Michigan
June 8, 2021

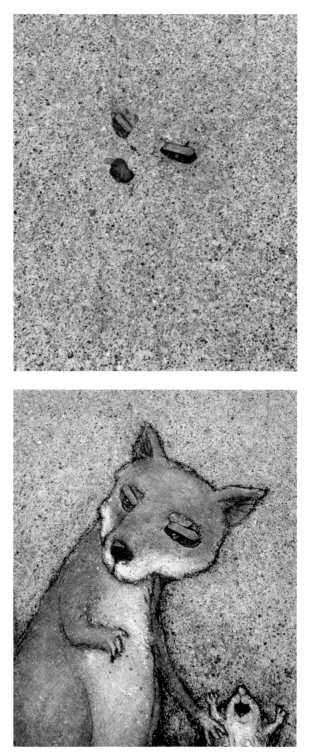

And that was the day Sandra learned you can't tickle just one hedgehog.

Ann Arbor, Michigan
May 19, 2021

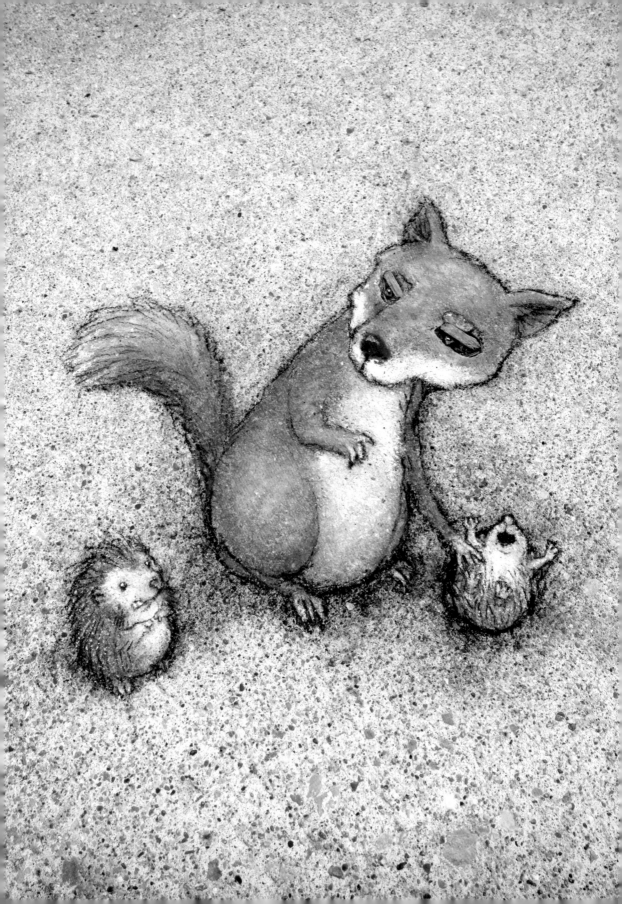

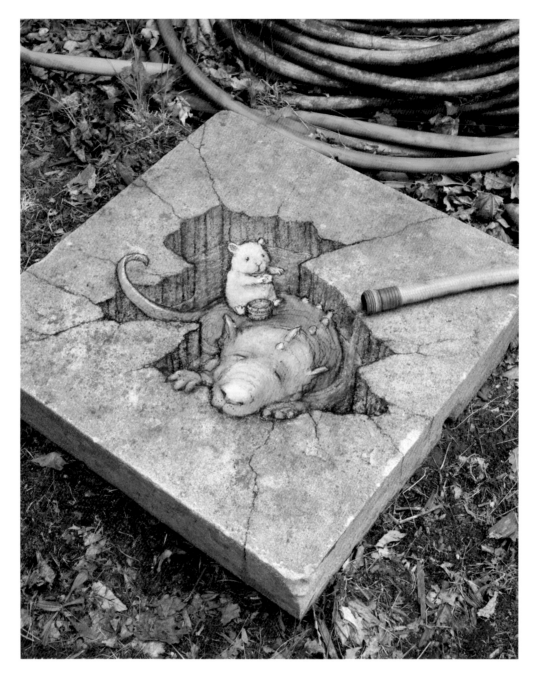

Bath Night

Ann Arbor, Michigan
May 13, 2021

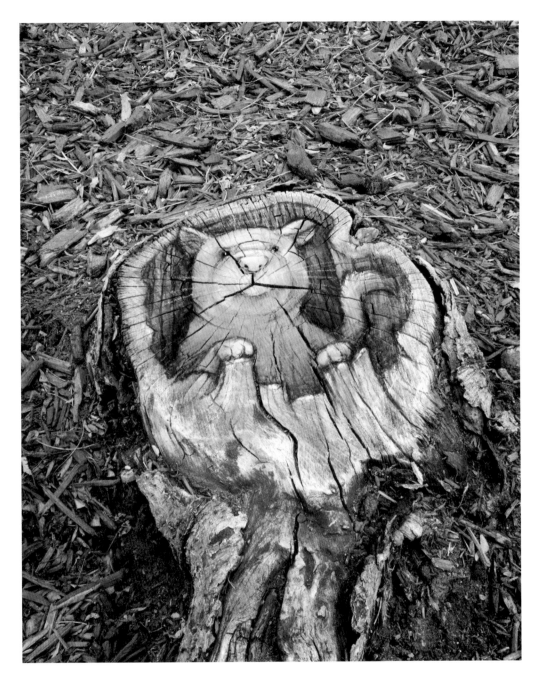

Waiting at the Wrong Stump

Ann Arbor, Michigan
May 25, 2021

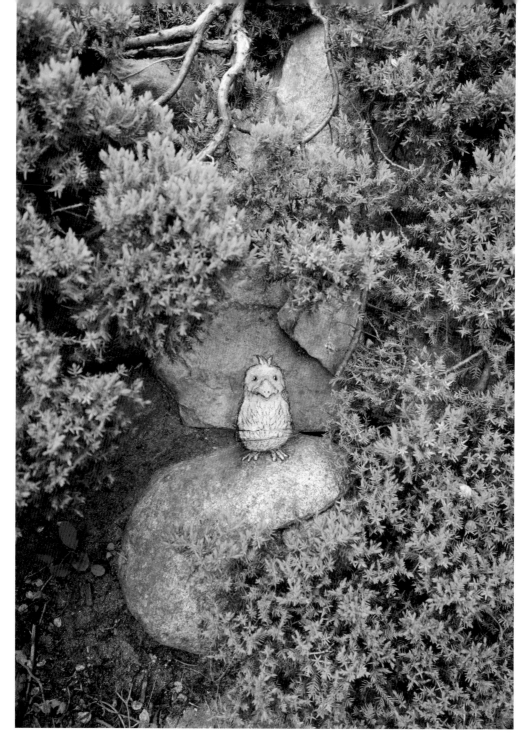

After a long search, Sean has found his fortress of
prickly solitude.

Ann Arbor, Michigan
May 18, 2021

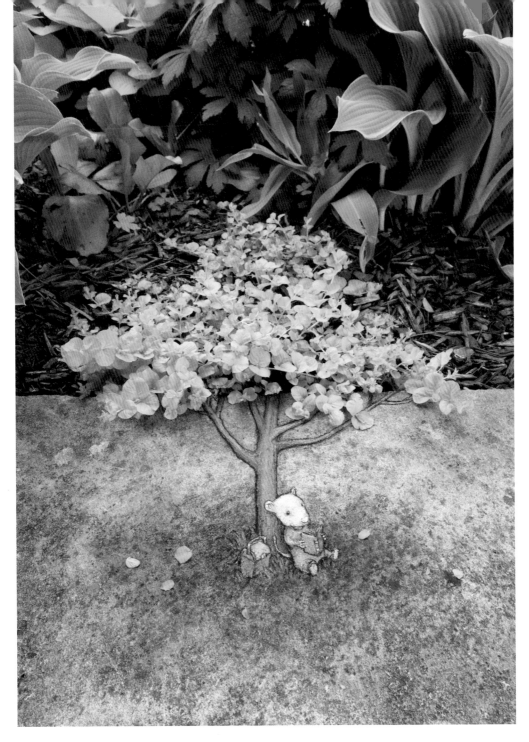

Nadine and the Chartreuse Respite

Ann Arbor, Michigan
May 16, 2021

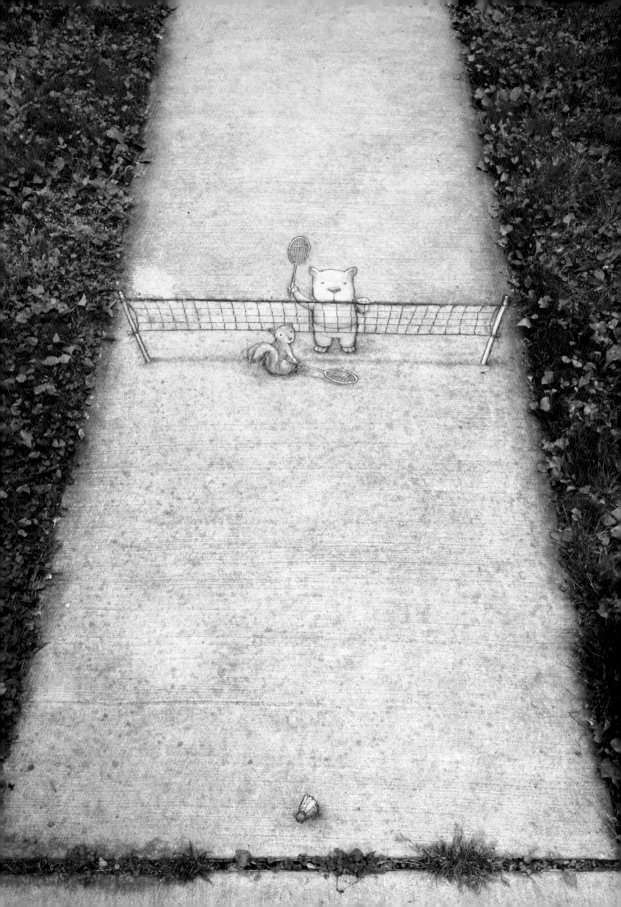

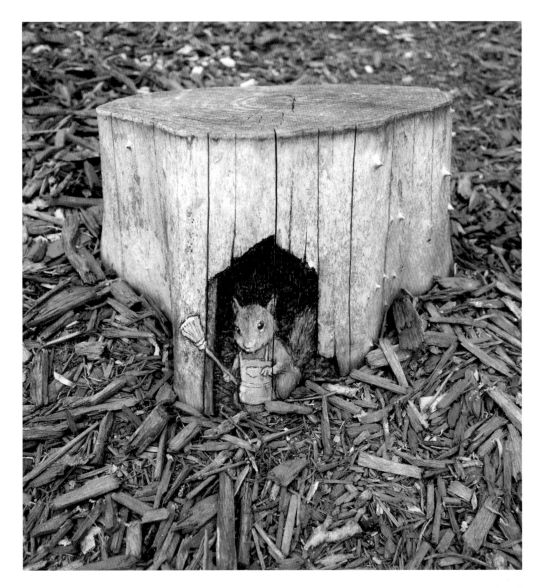

Sal gets even more determined
when the chips are down.

Ann Arbor, Michigan
May 12, 2021

←

A Little Help?

Ann Arbor, Michigan
May 27, 2021

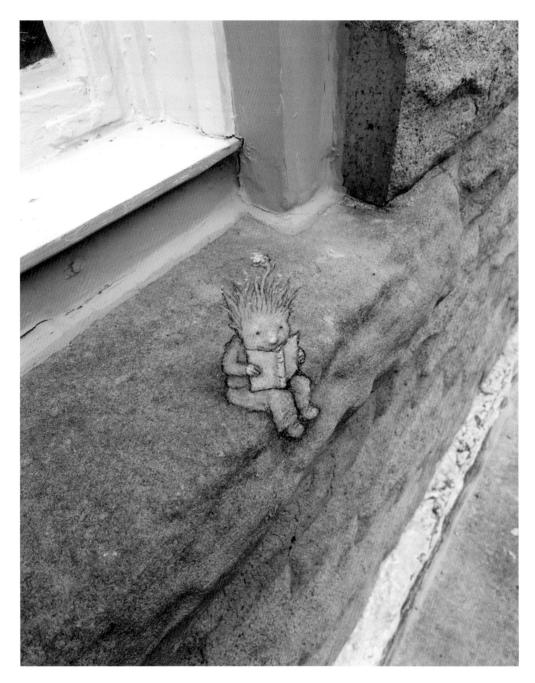

Reading is Enflowering

Columbus, Indiana
August 1, 2021

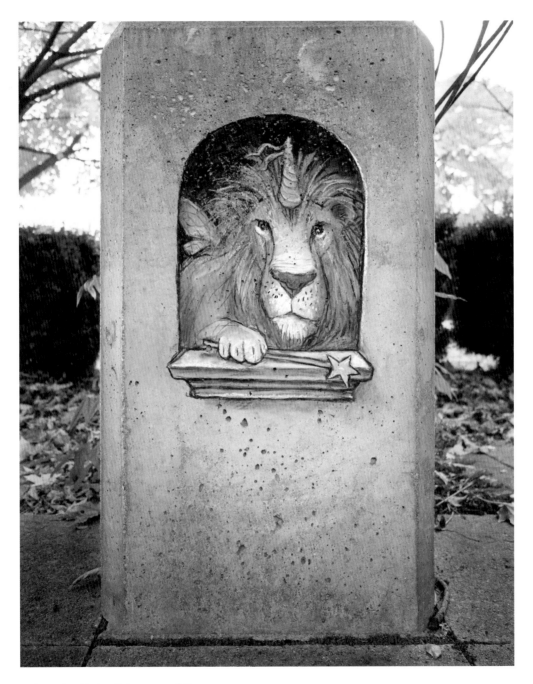

Brian, the Fairy Princess of Beasts

Detroit, Michigan
October 26, 2019

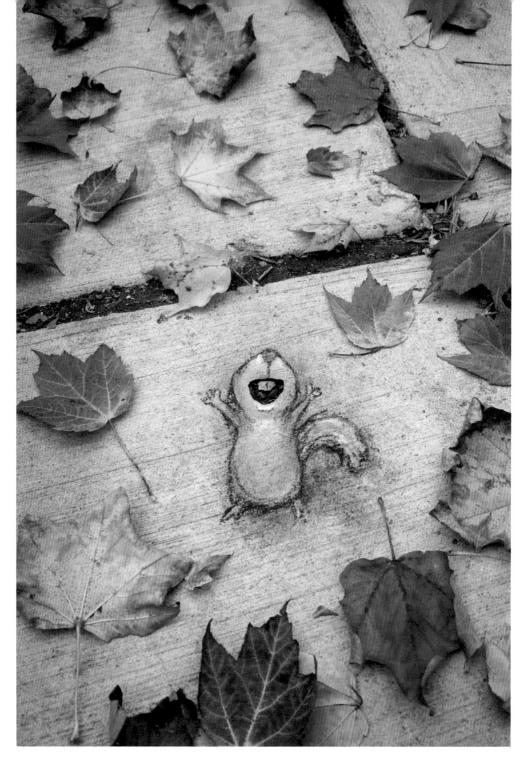

Leafy Elation

Ann Arbor, Michigan
October 21, 2019

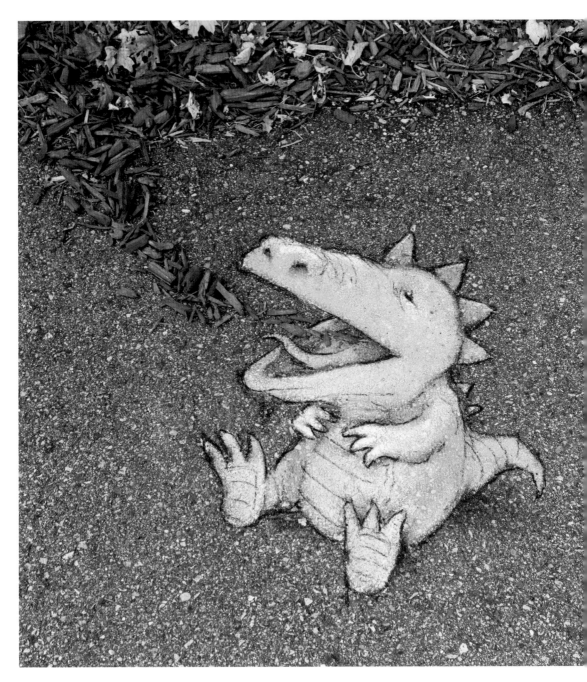

It's been a rough week, but Gordon is still chipper.

Ann Arbor, Michigan
October 8, 2020

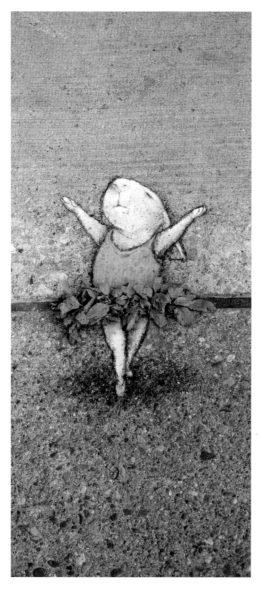

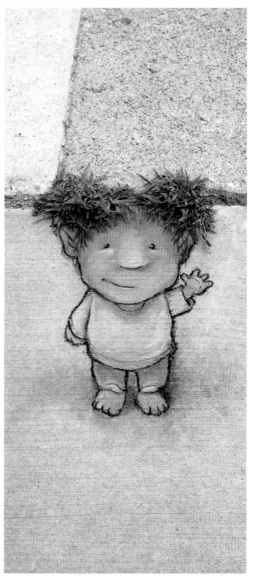

Rabbit ballet requires focus and
willpower because the tutus are
delicious.

Ann Arbor, Michigan
June 30, 2021

Fran's summertime hairstyle is
100 percent natural with very
healthy roots.

Ann Arbor, Michigan
July 21, 2021

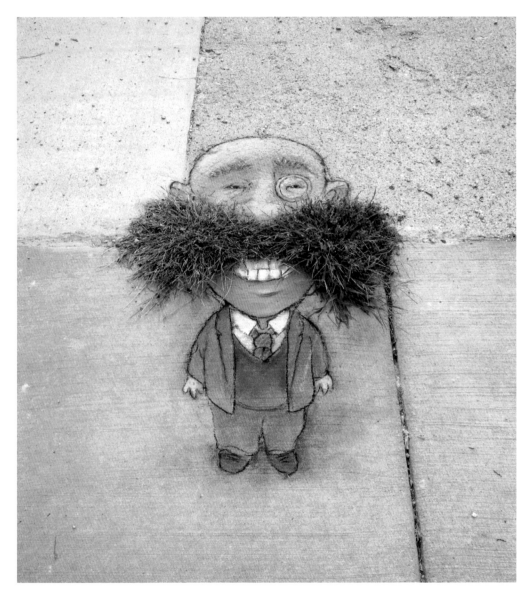

Leonard's motto: Cultivate abundance where you find it.

Ann Arbor, Michigan
September 12, 2020

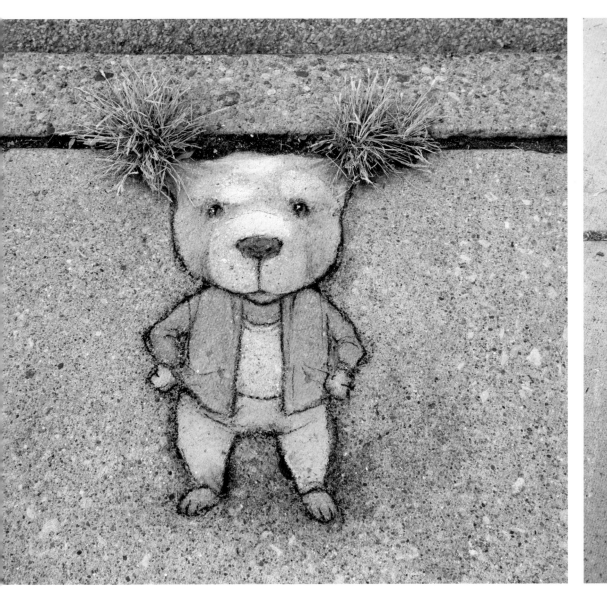

Sheila welcomes your comments on her new haircut.

Ann Arbor, Michigan
November 5, 2020

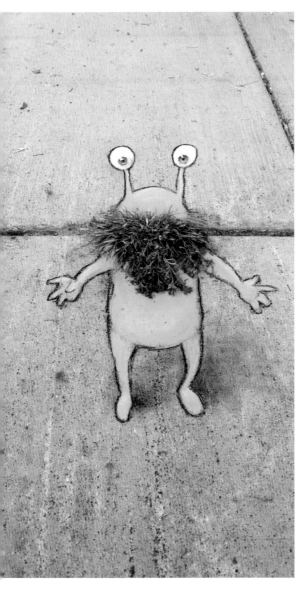

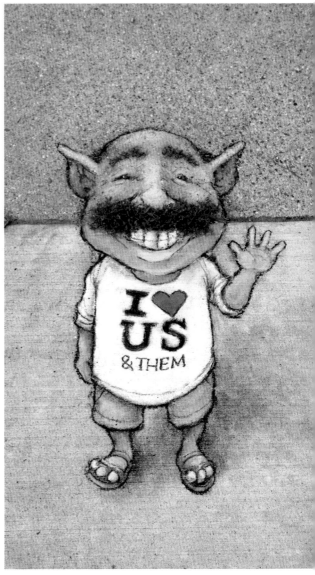

I don't know if Sluggo's summer project was to grow a beard or eat more greens. Either way, it's going great.

Ann Arbor, Michigan
August 20, 2020

Deeply Rooted Loyalties

Ann Arbor, Michigan
July 4, 2020

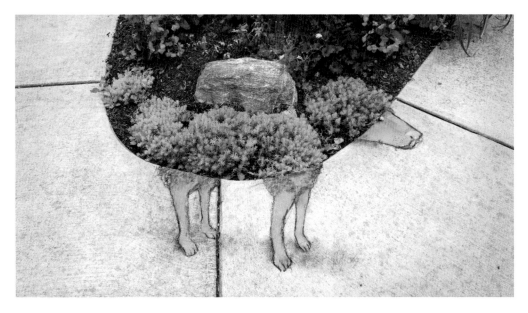

The Verdapoodle doesn't look very fast, but she actually covers a lot of ground.

Taylor, Michigan
August 10, 2018

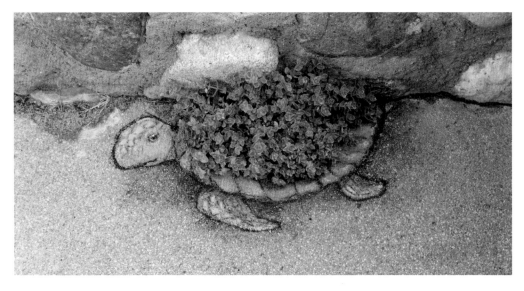

Fertile-Backed Turtle

Laguna Beach, California
March 29, 2019

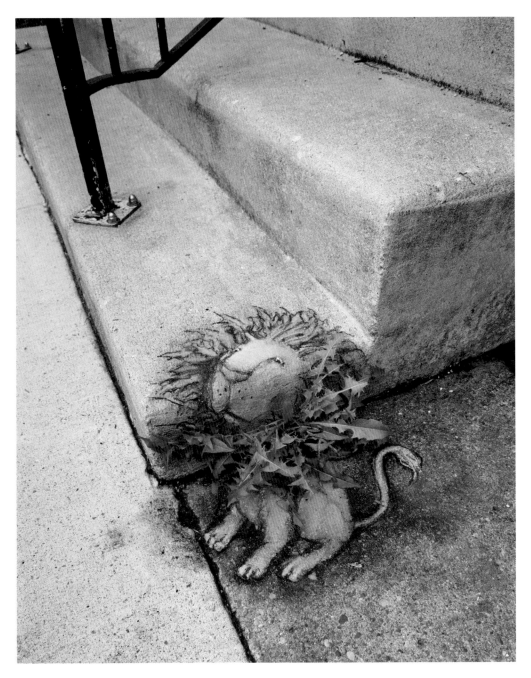

May also comes in like a lion, but it's a dandier one.

Ann Arbor, Michigan
May 7, 2019

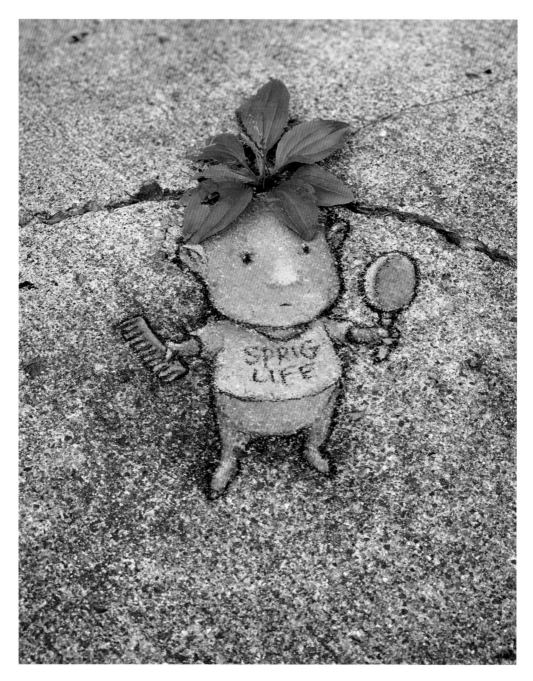

Dana puts a lot of effort into looking this natural.

Ann Arbor, Michigan
July 25, 2019

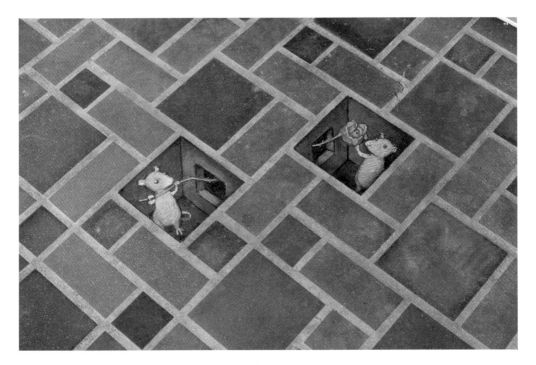

**Holding the Thorns to
Share the Bloom**

*Ann Arbor, Michigan
June 2, 2020*

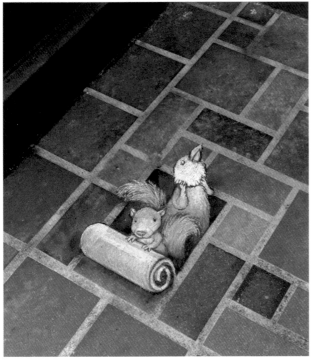

**Planning the Great
Birdfeeder Heist**

*Ann Arbor, Michigan
May 19, 2020*

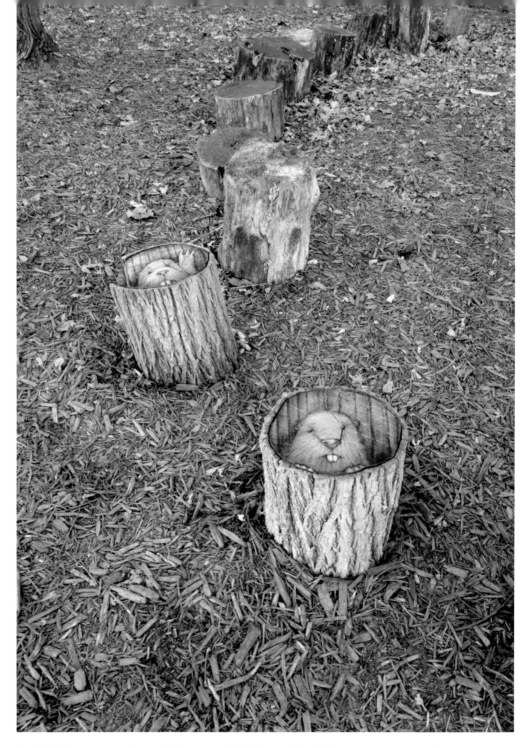

I asked these guys for advice on social distancing. They were stumped.

Ann Arbor, Michigan
March 17, 2020

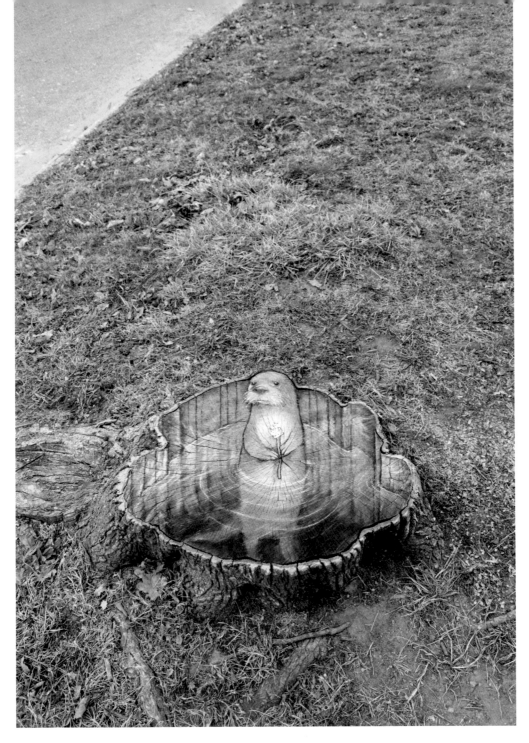

Gerald's Blind Date, 6:05 PM

Ann Arbor, Michigan
March 21, 2021

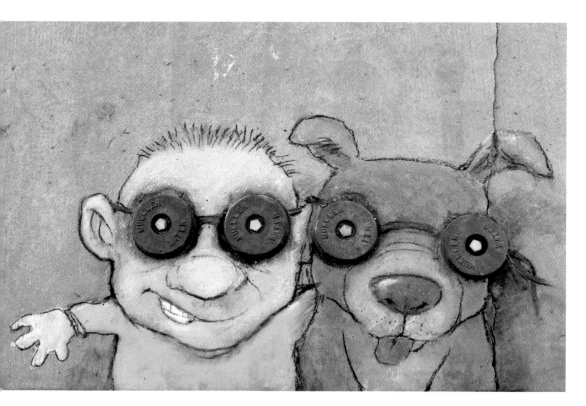

Ernie "Goggles" Granger and his dog, Specs

Ypsilanti, Michigan
February 22, 2020

→

This building has seen better days.
Luckily, Edith is a load-bearing possum.

Ann Arbor, Michigan
October 2, 2019

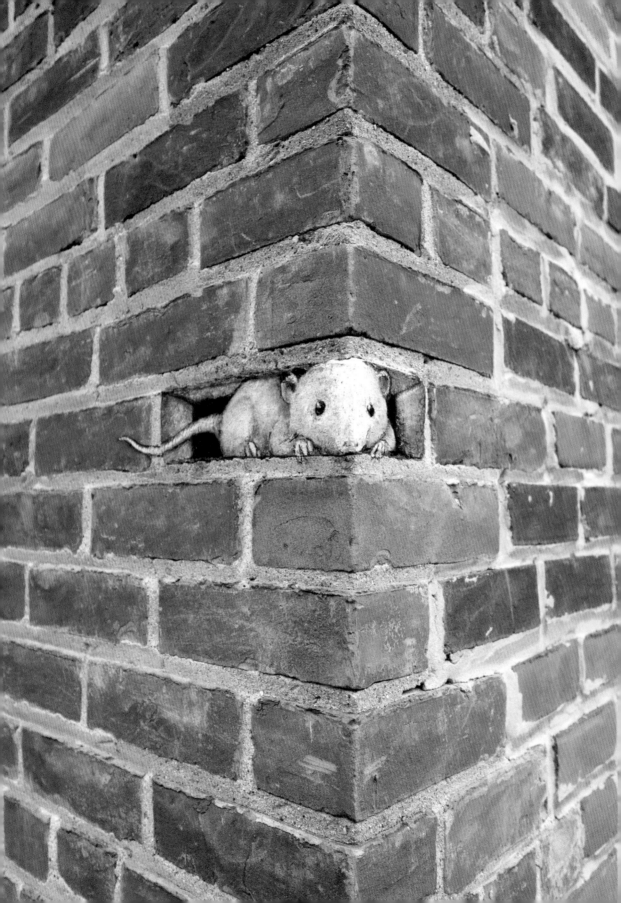

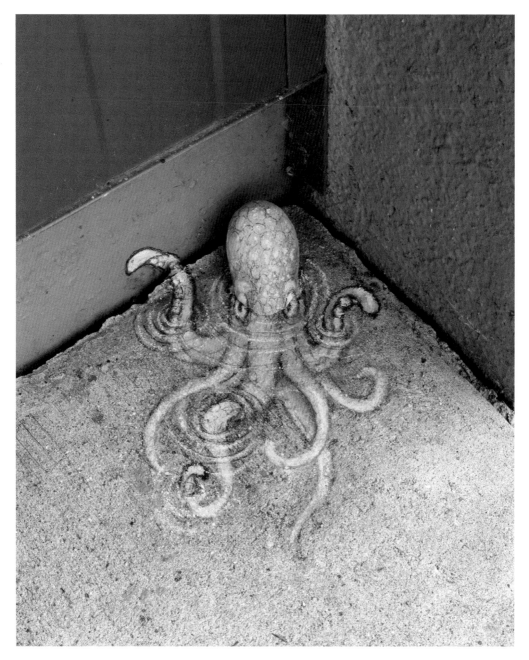

Beware the Rocktopus!

Belle Isle, Michigan
August 20, 2018

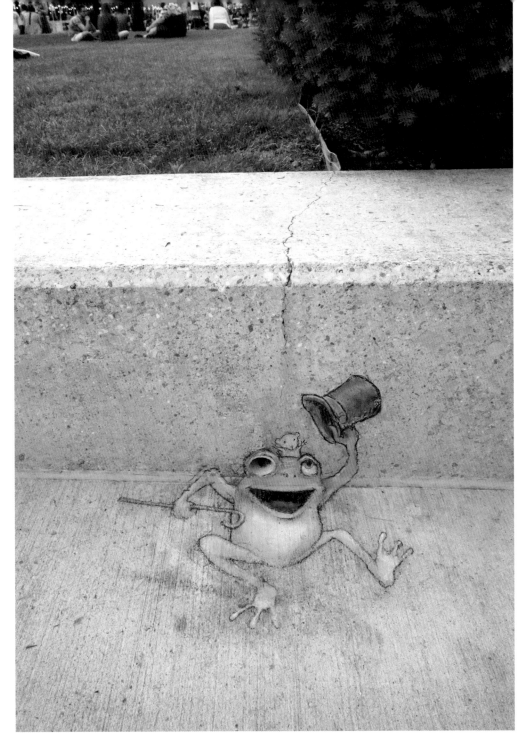

Fancy footwork is all well and good, but it's the tiny little jazz hands that sell the act.

Ann Arbor, Michigan
June 23, 2018

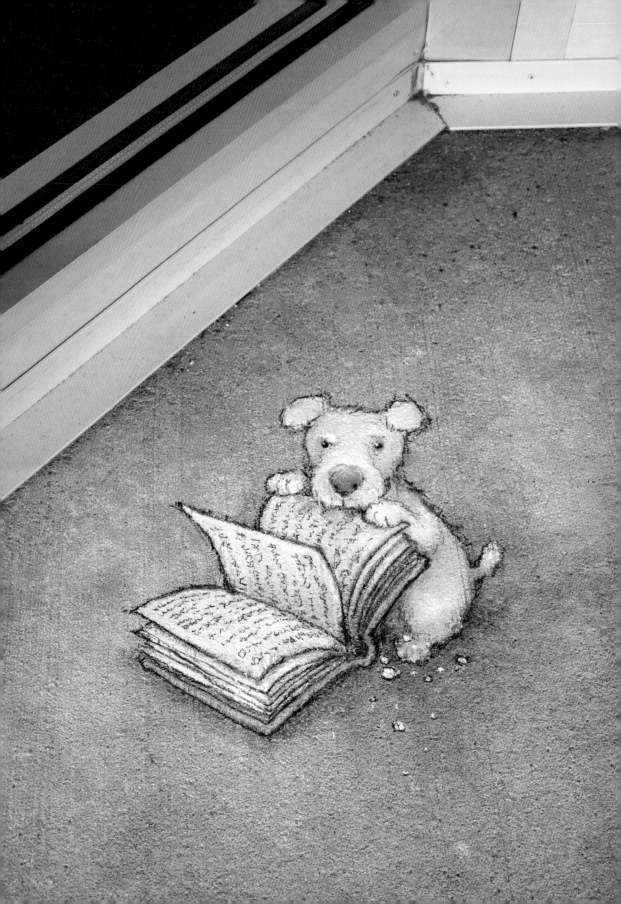

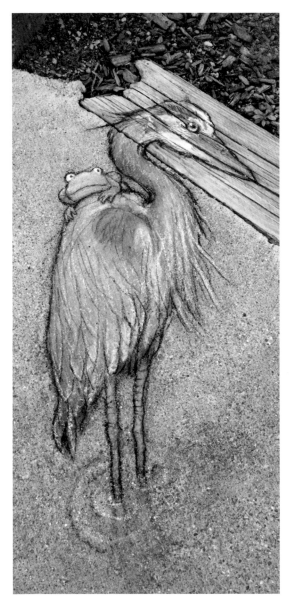

Friends in High Places

Ann Arbor, Michigan
June 17, 2021

←

Sparky's ultimatum: More treats or you'll never find out if the butler did it.

Ann Arbor, Michigan
July 12, 2021

If you lost a pink and purple glove at the corner of Fourth and William, Spegnatz the Cold-Footed thanks you.

Ann Arbor, Michigan
January 14, 2021

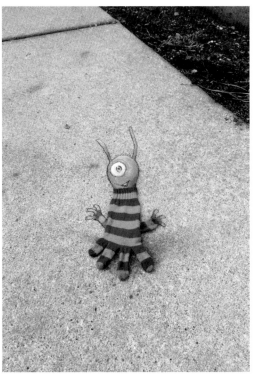

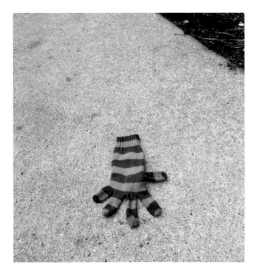

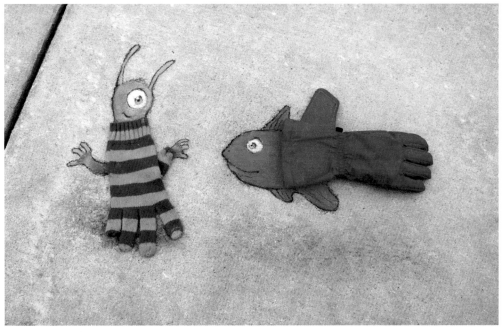

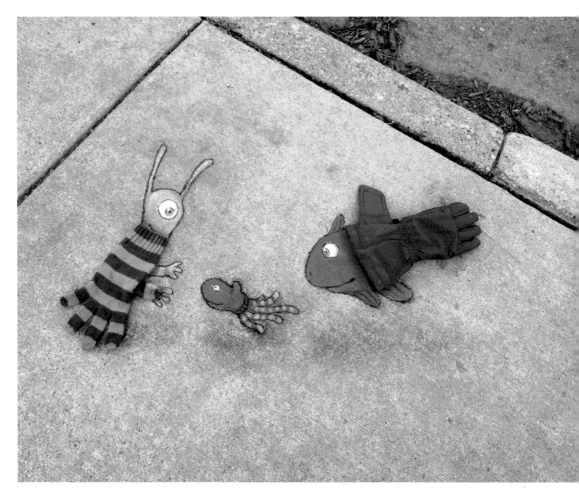

Signs of Spring in the Lost Glove Department

Ann Arbor, Michigan
March 4, 2021

←

Lost and Found

Ann Arbor, Michigan
February 12, 2021

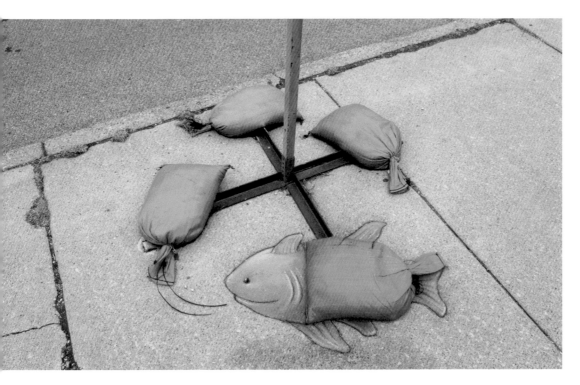

Simon's friends don't talk much, but they're really down-to-earth.

Ann Arbor, Michigan
May 4, 2021

—>

The Sandbag Bandit is known for his fearlessness,
guile, and high center of gravity.

Ann Arbor, Michigan
June 2, 2020

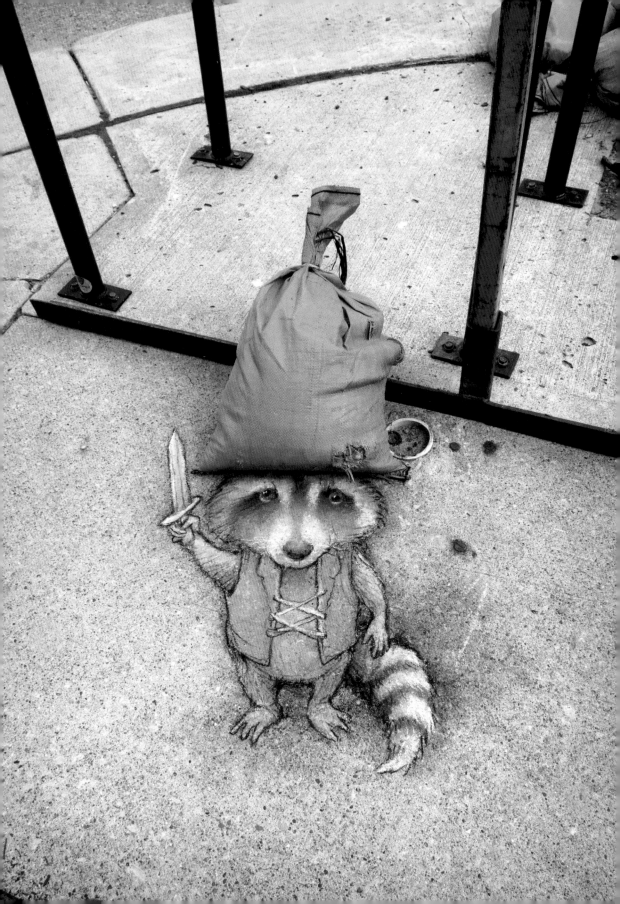

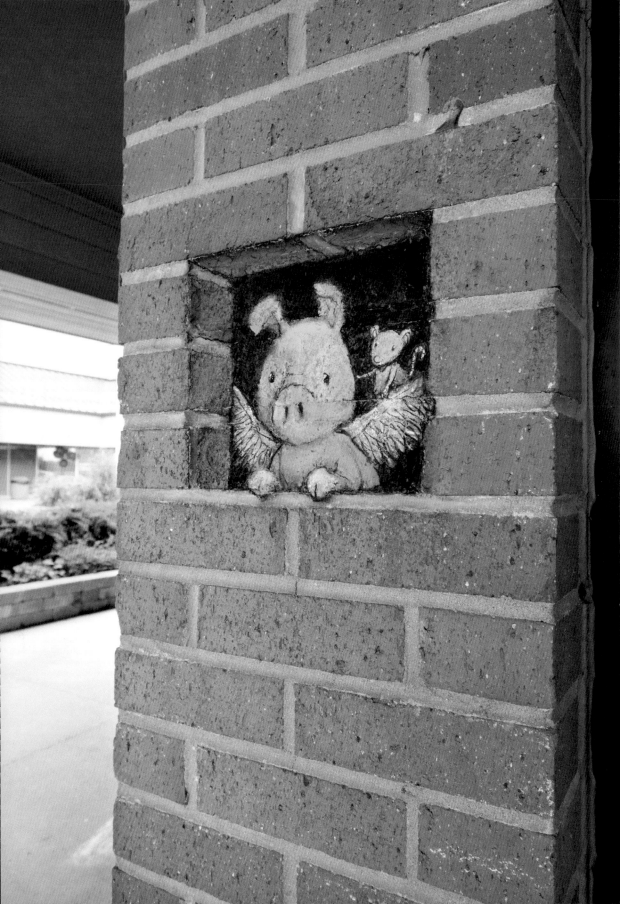

PHILOMENA,
THE PATRON PIG OF IMPOSSIBILITY

Philomena likes to start her days by watching for
the second most impossible thing to happen.

Ann Arbor, Michigan
July 19, 2021

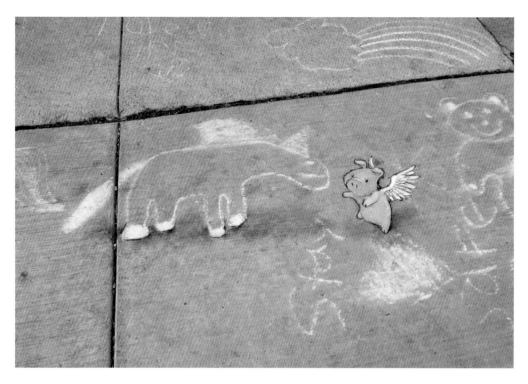

Networking at the 2021 Symposium of
Imaginary Friends and Impossible Creatures

Ann Arbor, Michigan
March 23, 2021

Wash Your Hands

Ypsilanti, Michigan
July 8, 2020

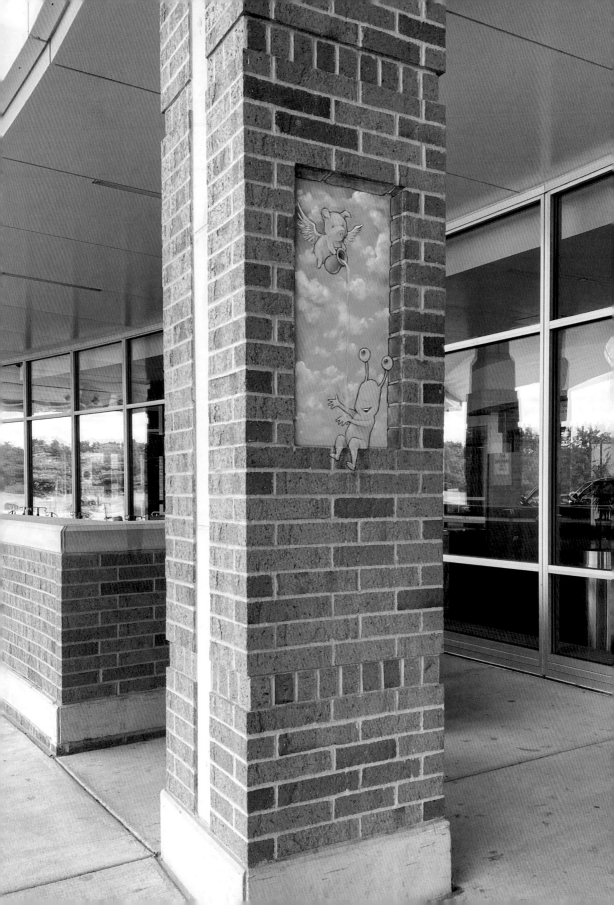

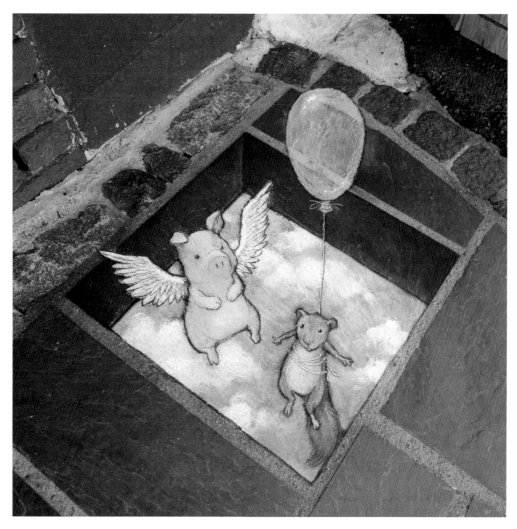

When pigs fly, the squirrels will get inventive.

Ann Arbor, Michigan
April 19, 2021

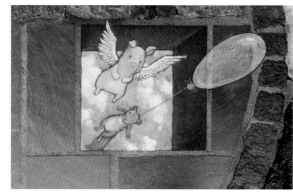

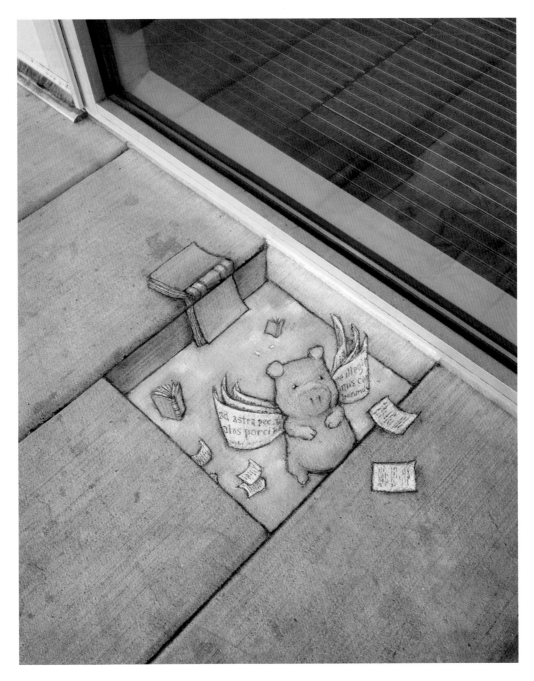

Philomena is a big fan of escapist literature.

Ann Arbor, Michigan
July 12, 2021

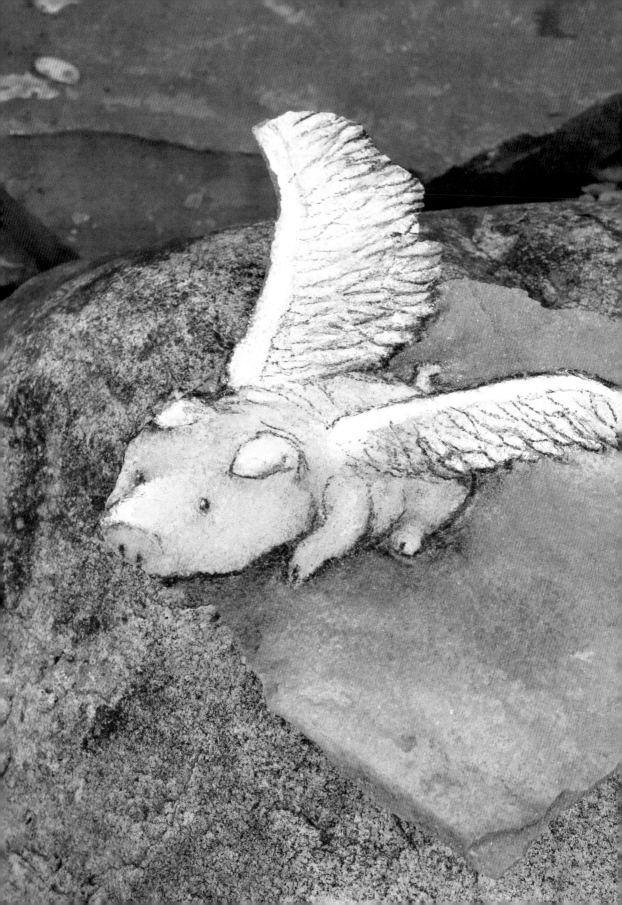

As the story goes, John Steinbeck was told by one of his professors that he would become an author when pigs fly, which is why he imprinted all of his published books with the symbol of a winged pig surrounded by the phrase "ad astra per alia porci" meaning "to the stars on the wings of a pig."

It's a satisfying tale of overcoming discouragement from a figure of authority, and the symbol of the Pigasus is itself a useful image of hope and humility (Steinbeck described himself as "a lumbering soul but trying to fly") that I clearly resonate with to a fault.

However, there is an extra moral to the story, which I feel all the more keenly as the grandson, son, brother, and nephew of teachers: he got the Latin wrong. The accurate phrase is "ad astra per ALAS porci," which means that Steinbeck in his snarky revenge was demonstrating far and wide that he was a bad student after all—and thanks to his famous but inaccurate imprint, countless people are running around with tattoos which actually say "to the stars through other pigs."

TL;DR: The more resentful you feel, the more important it is to proofread carefully.

Ann Arbor, Michigan
October 28, 2019

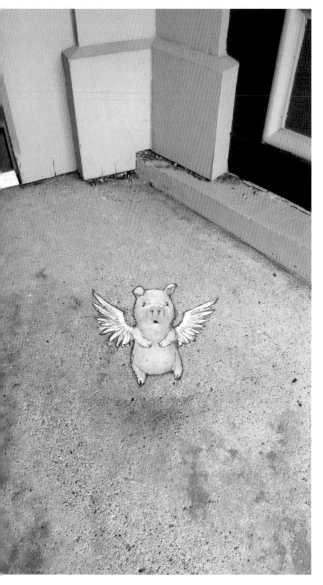

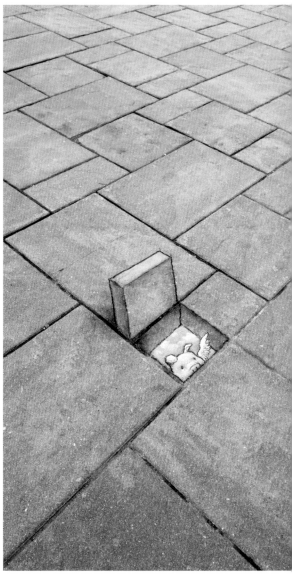

Nonplussed Pigasus
(I'll stop drawing flying pigs when
they stop making faces at me.)

Ann Arbor, Michigan
June 24, 2021

Generally but especially at this time
of year, it's advisable to keep the hope
hatch ajar.

Ann Arbor, Michigan
November 16, 2020

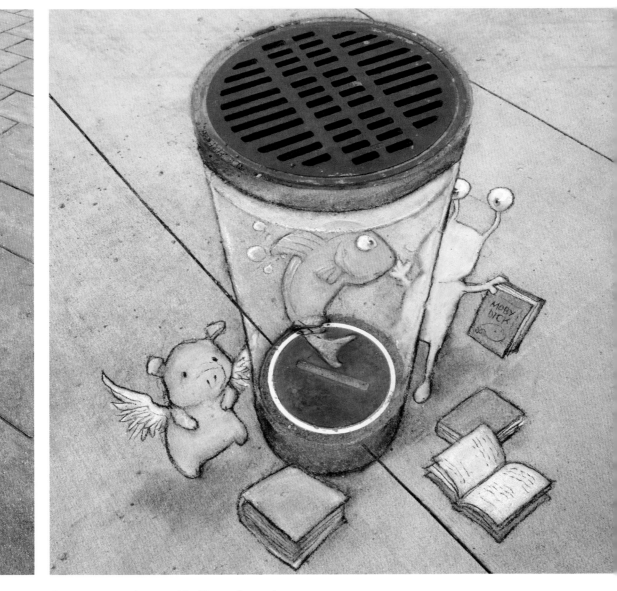

Give a man a fish and he'll eat for a day.
Teach a fish and he'll dream of being a whale.

Columbus, Indiana
September 18, 2018

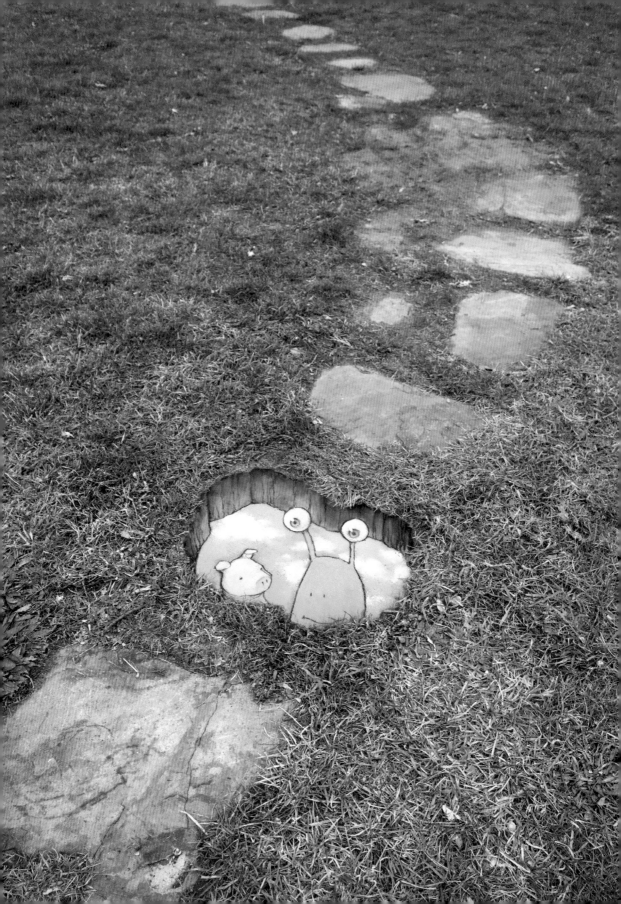

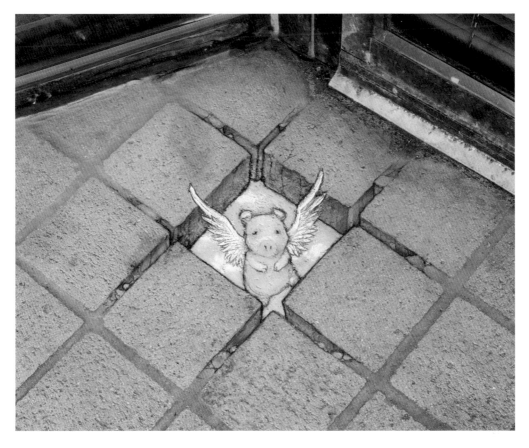

Looks like another long day of things
stubbornly refusing to be impossible.

Ann Arbor, Michigan
July 15, 2021

←

I don't know if this is an endorsement of sticking
to the narrow path or a warning against it, but
either way, watch your step.

Ann Arbor, Michigan
April 12, 2020

"Never Waste a Rainbow-Barfing Cloud"
Collaboration #2 with local artist Lula June Cook

Ann Arbor, Michigan
July 12, 2020

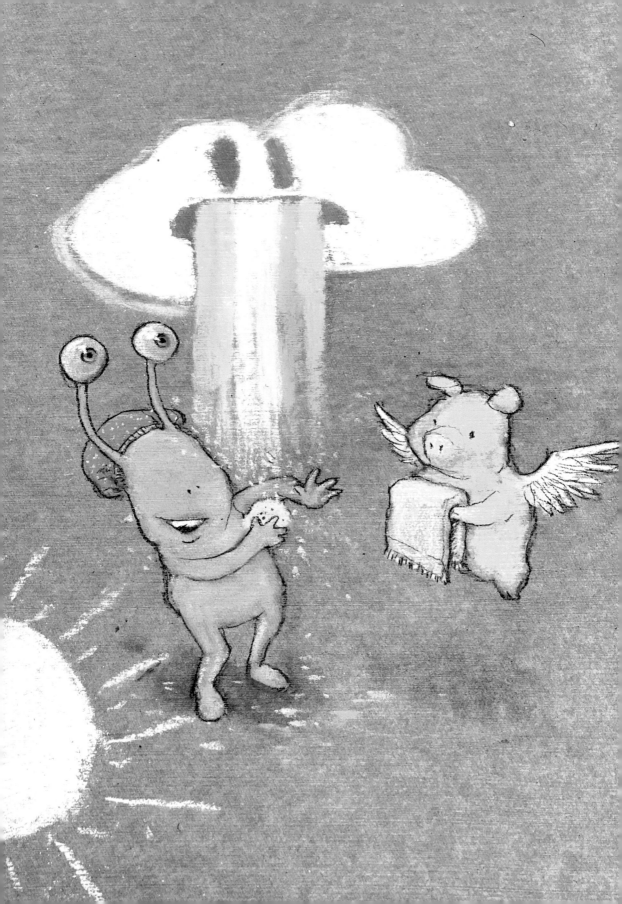

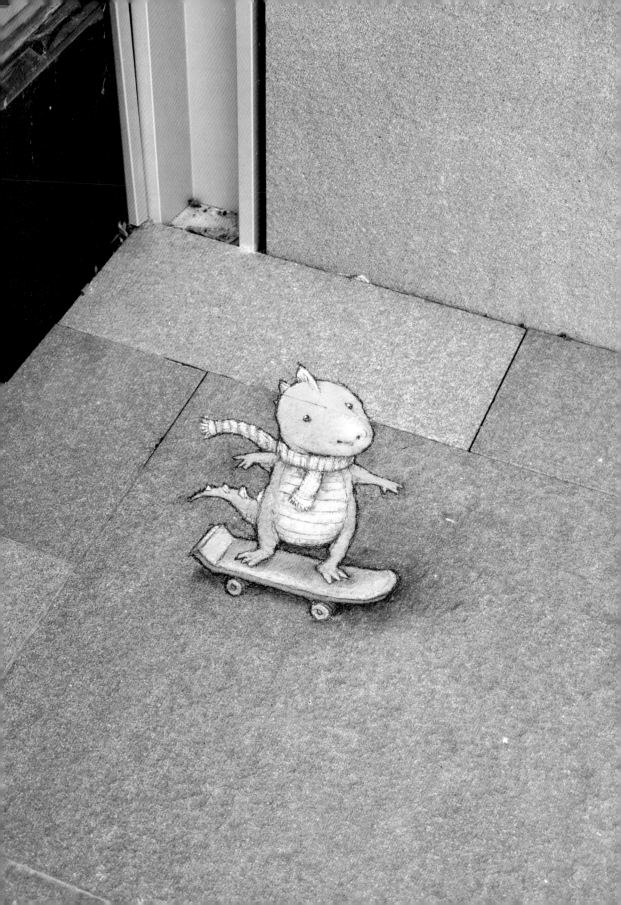

THE CORNER

AROUND

AND DOWN THE PATH

Vincent is getting really good at this balancing thing. Tomorrow he might try rolling forward a little.

Ann Arbor, Michigan
April 25, 2021

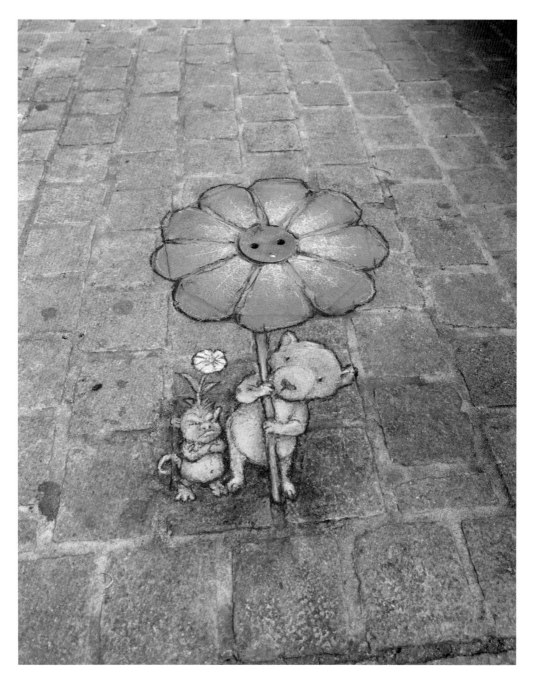

Be a Bloom that Shades No Others

Fürth, Germany
May 27, 2019

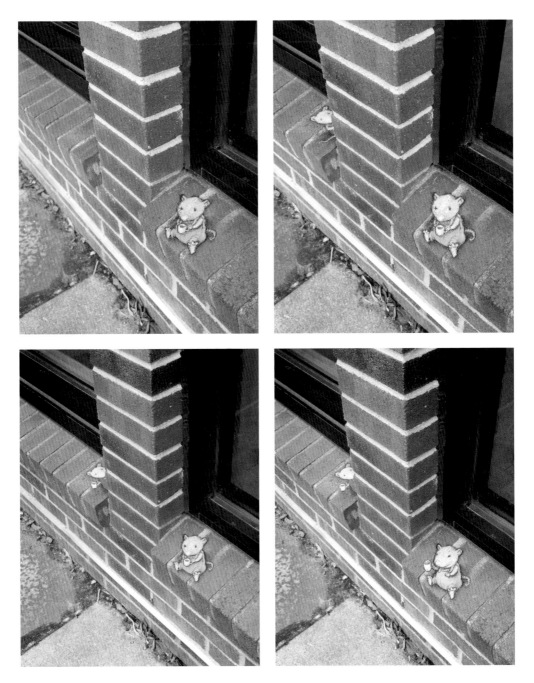

A neighborly intervention in four acts.

Ann Arbor, Michigan
March 25, 2020

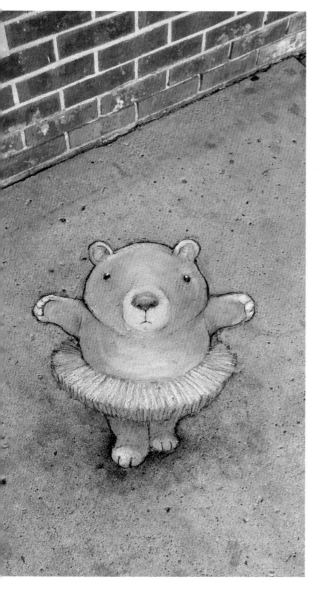

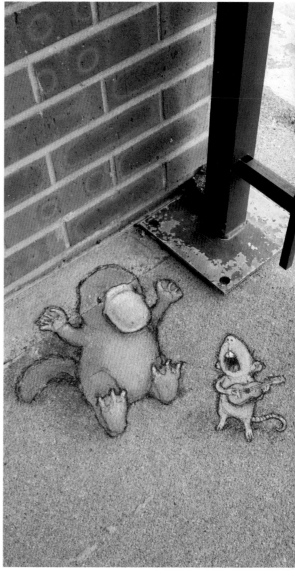

After several lessons, Sasha has learned that ballet requires practice, poise, and elbows.

Ann Arbor, Michigan
April 23, 2020

Janine loves live music, but it's mostly an excuse to applaud.

Ann Arbor, Michigan
May 11, 2021

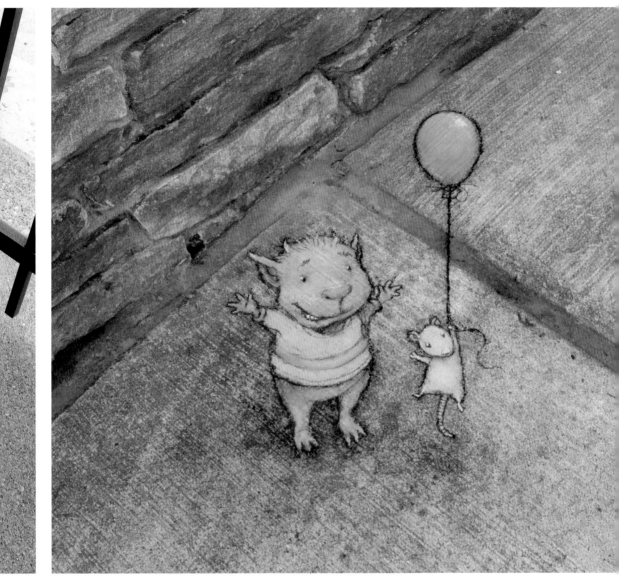

Truth be told, Ruth and Melvin's Amazing Levitation Extravaganza is short on mystery and long on "ta-daaa!"

Ann Arbor, Michigan
April 25, 2021

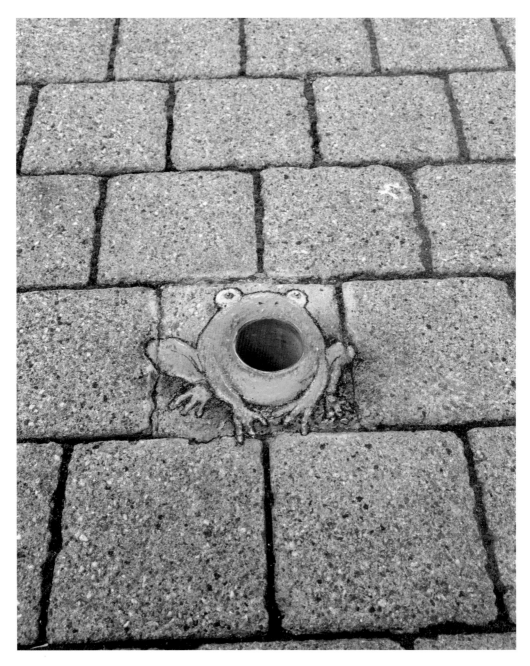

Fish gotta swim, birds gotta fly, frogs gotta sing songs straight at the sky.

Fürth, Germany
May 24, 2019

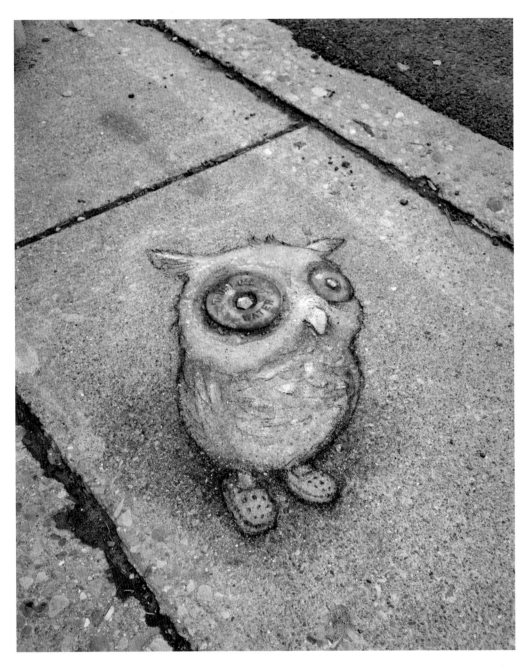

Simon stood quietly and waited for someone to compliment his new shoes.

Ann Arbor, Michigan
March 27, 2021

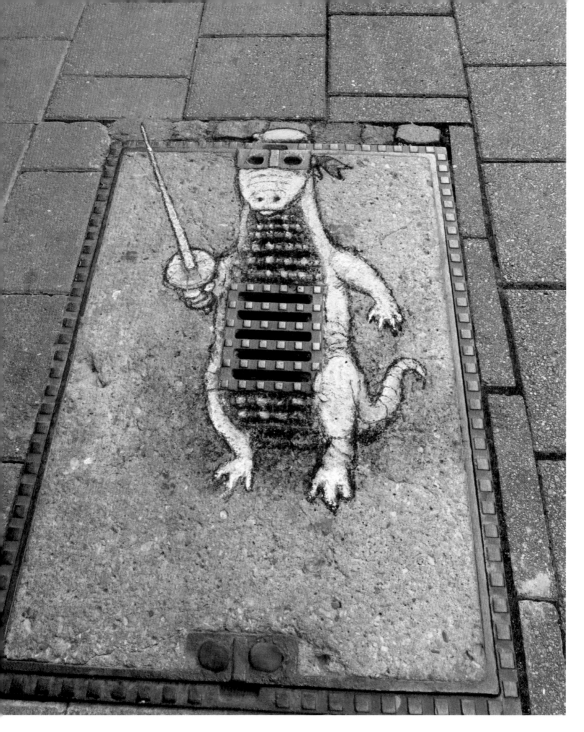

Zorrosaurus

Fürth, Germany
May 25, 2019

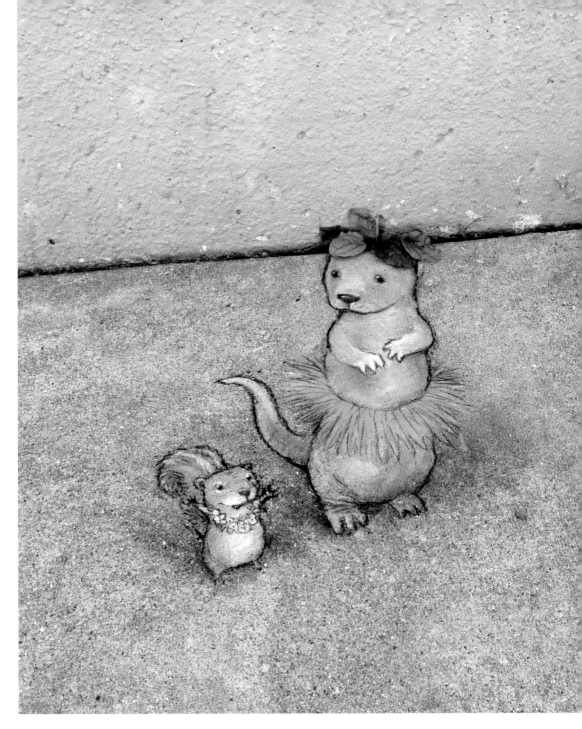

Despite general enthusiasm for the luau theme,
Hedda remains anxious about her southern exposure.

Detroit, Michigan
October 12, 2019

A brief between-rainstorms interlude by Augustus the Flautomaton

Ann Arbor, Michigan
August 1, 2020

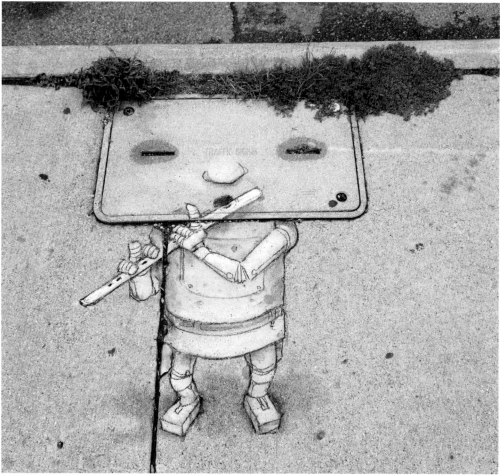

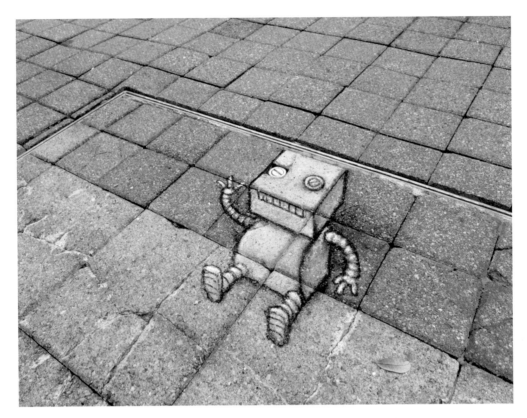

Met this guy in Hermann Square just
before the rain chased him away ...
but I bet he still has an eye on things.

Houston, Texas
November 21, 2018

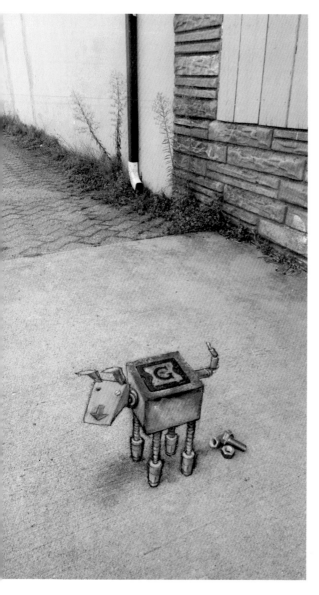

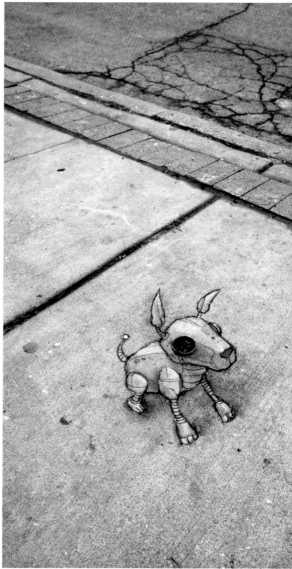

Rover Unit G used to be house trained, but he's getting a little rusty.

Onset Bay, Massachusetts
August 27, 2018

Missing: one Rover-CR Spheroid Retrieval Unit. Answers to "Rusty."

Ann Arbor, Michigan
January 15, 2020

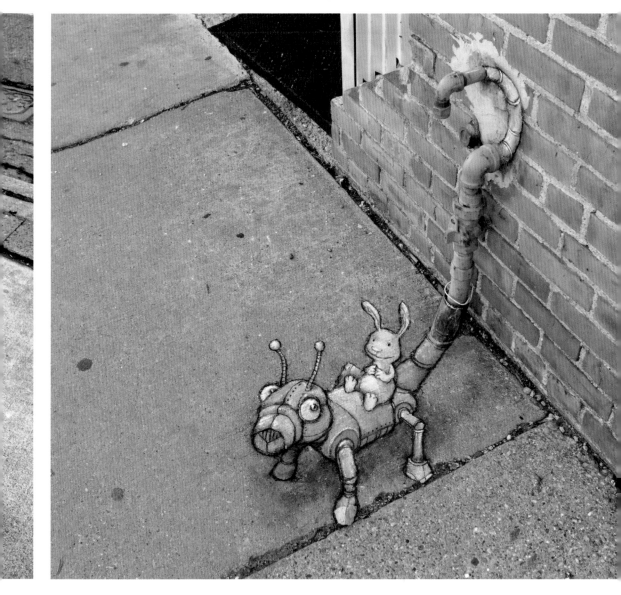

Shirley has very few needs, but a robotic long-tailed pet lizard-dog
was apparently high on that list.

Ann Arbor, Michigan
January 4, 2019

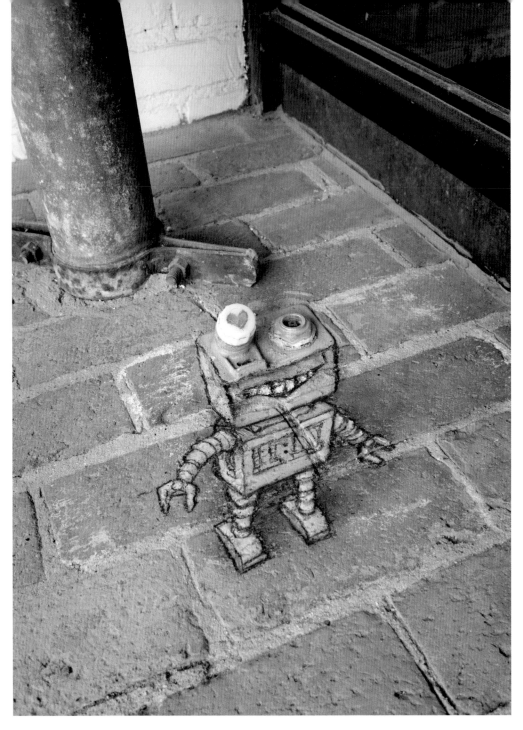

Beauty is in the eye of the Beholdatron 3000.

Ann Arbor, Michigan
April 7, 2021

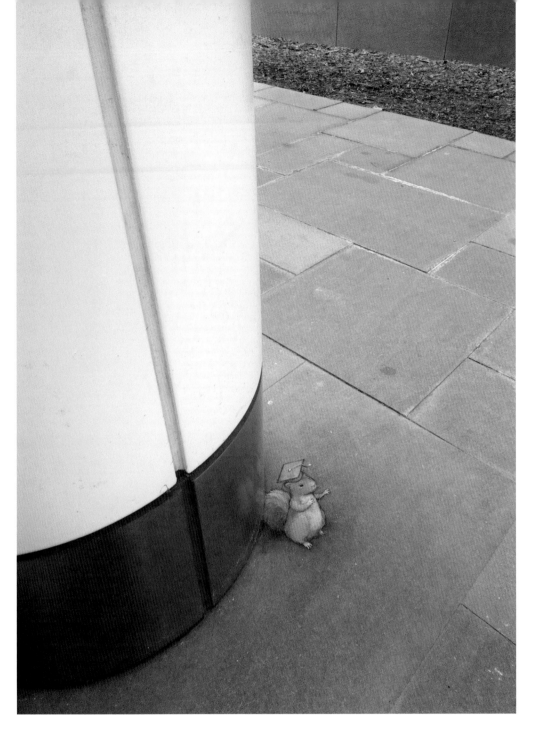

Away from the scurrying crowd, Francine practices her valedictorian speech at the School of Hard Nuts.

Ann Arbor, Michigan
April 25, 2021

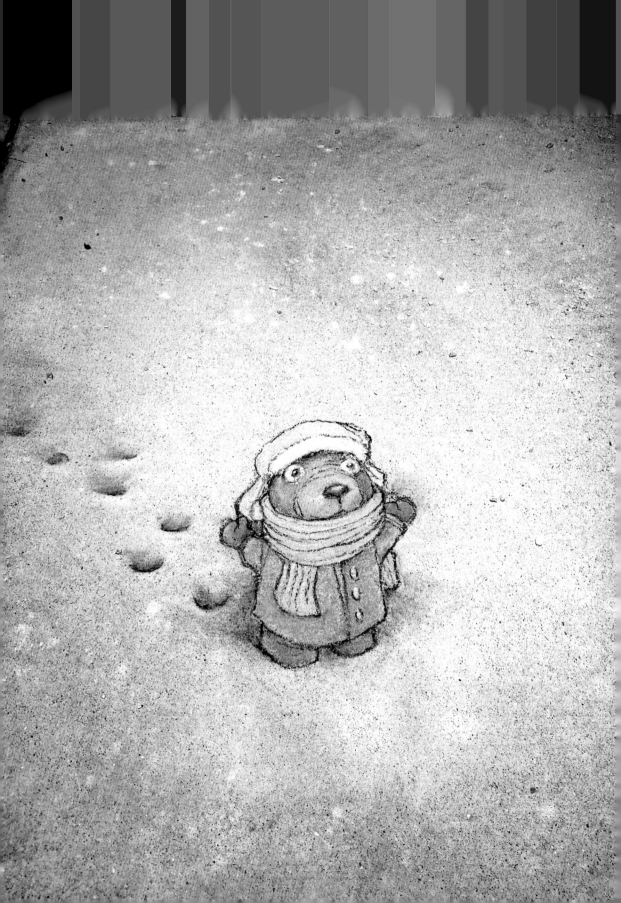

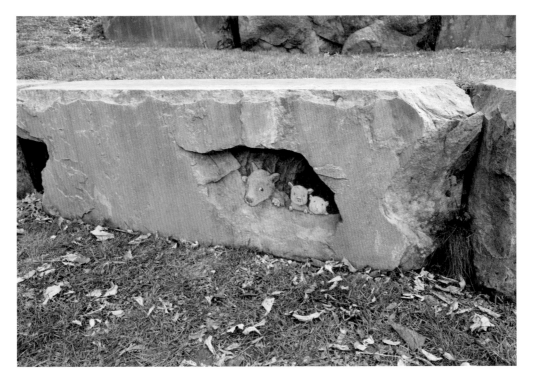

I don't know what it says about this year, but membership is booming in the Sixth Street Hibernation Club.

Ann Arbor, Michigan
November 29, 2020

←

Clyde was momentarily caught between awe for the falling snow and urgency to find a bathroom.

Ann Arbor, Michigan
January 19, 2021

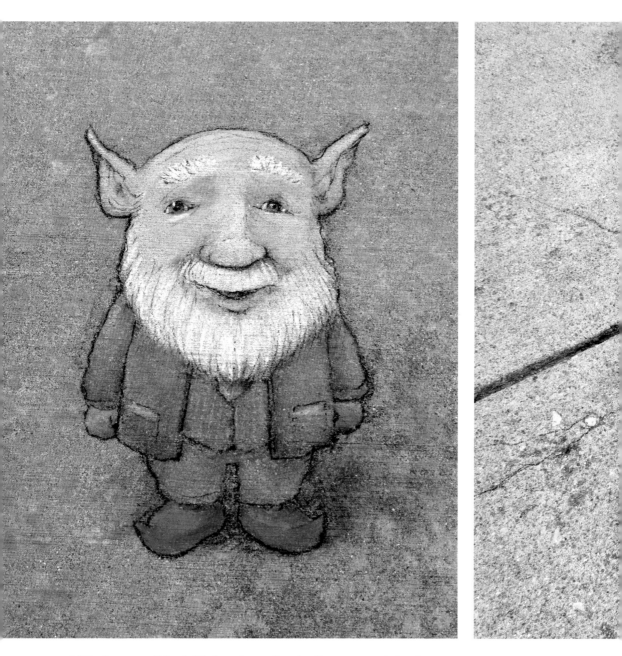

Little-known elf fact: Stefan doesn't actually wear pointy shoes.
His socks are full of tortilla chips.

Ann Arbor, Michigan
November 29, 2020

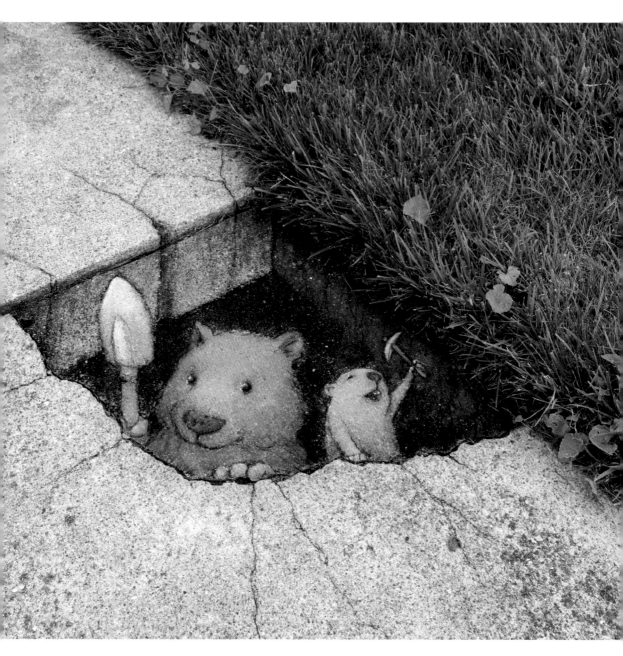

Wendell has calculated how many times he can hear "If I Had a Hammer" in one day, and Terry's about to lose his tiny pickaxe.

Ypsilanti, Michigan
September 4, 2020

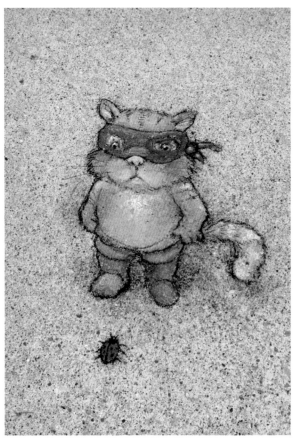

The Confrontation

Ann Arbor, Michigan
August 15, 2020

\longrightarrow

The Bollard Kid says this town ain't big
enough for the both of us, and yet there's
room for a family of five inside his hat.

Whitmore Lake, Michigan
August 29, 2020

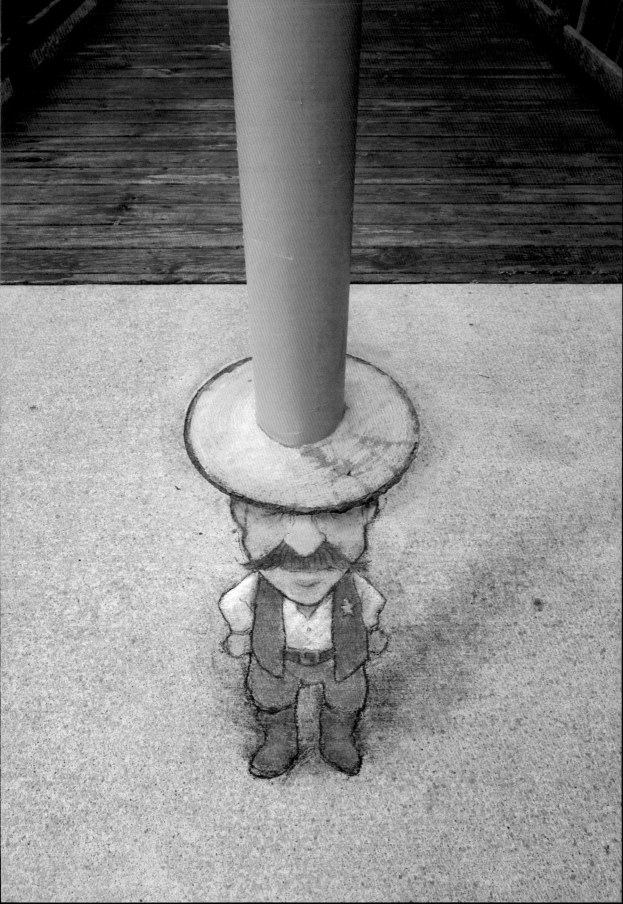

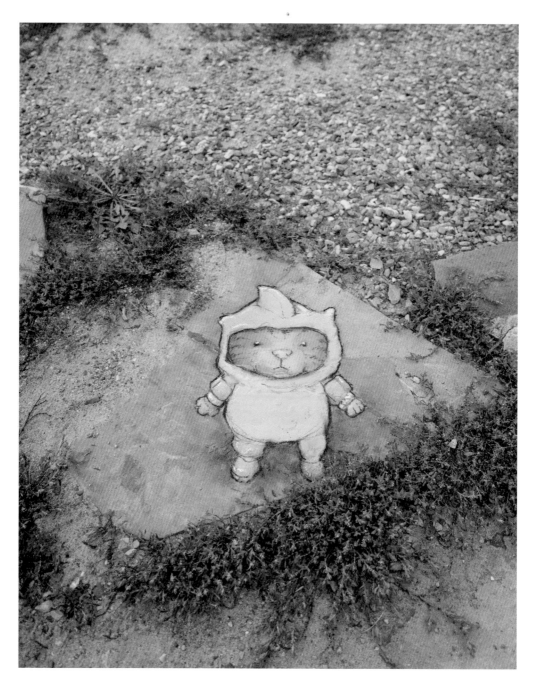

Kevin likes to swim but hates touching water.

Ypsilanti, Michigan
September 4, 2020

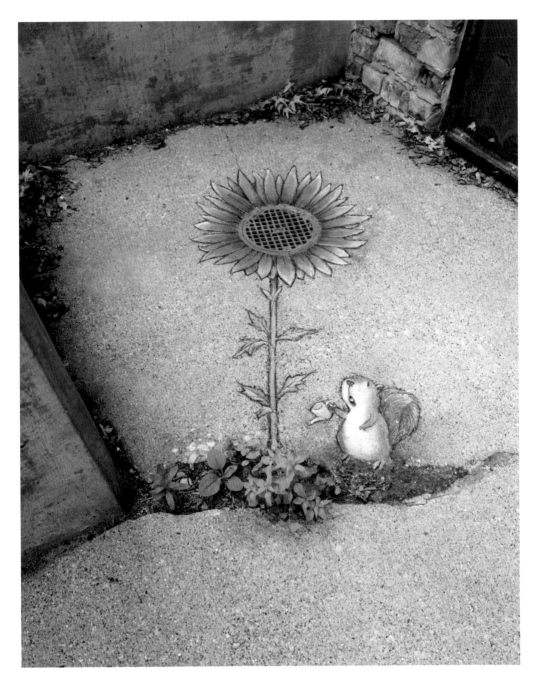

Unanticipated Bounty

Ann Arbor, Michigan
July 1, 2020

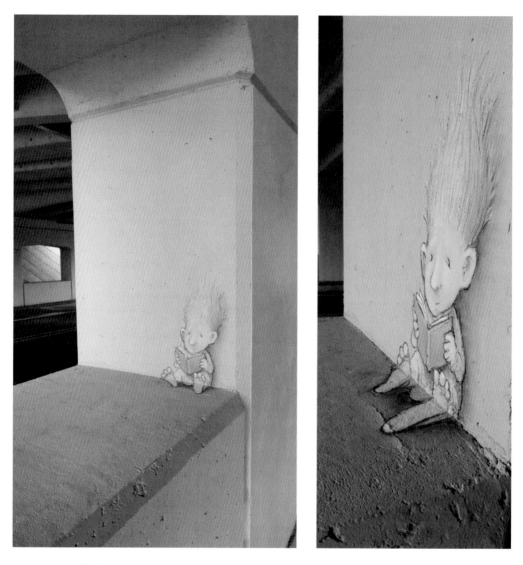

Underpass Troll
Whitmore Lake, Michigan
August 28, 2020

→

Greg spent his birthday enjoying
all of his favorite thing.
Ann Arbor, Michigan
April 19, 2020

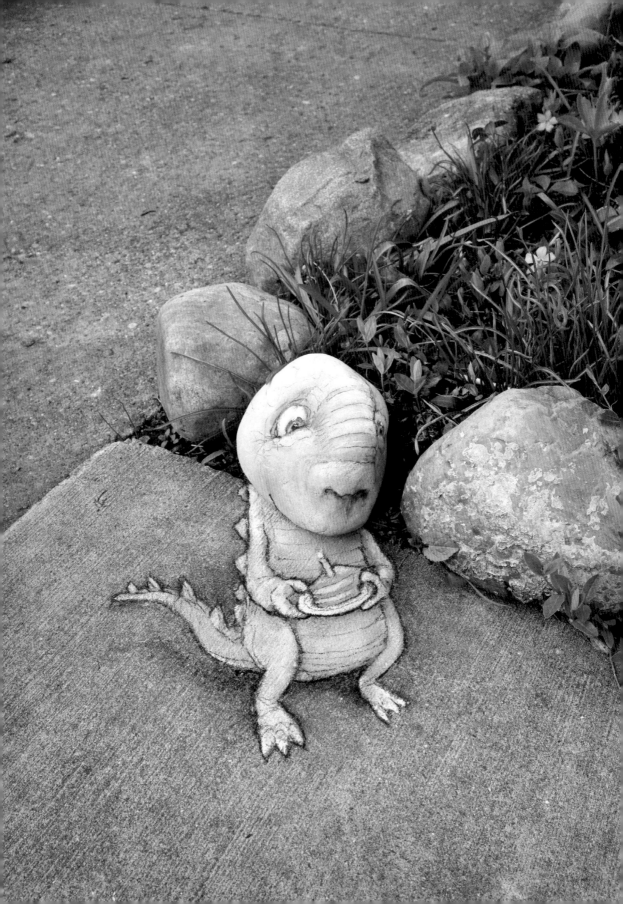

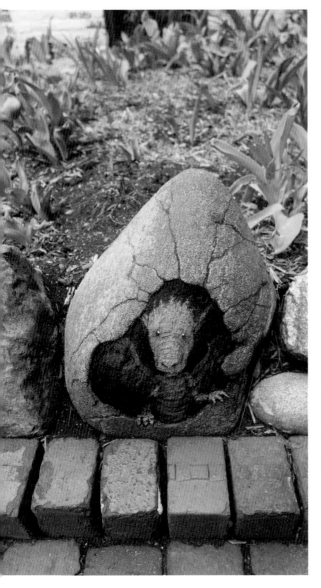

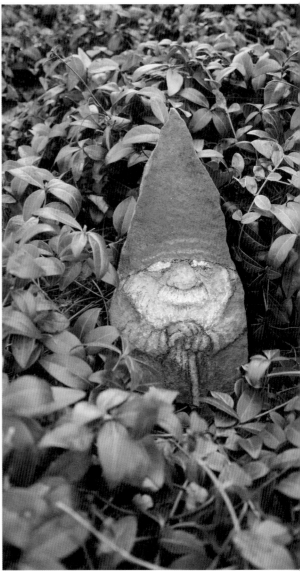

It's a good time of year to sit in the garden and watch little green things emerge.

Ann Arbor, Michigan
April 16, 2019

Rockshard the Gnome

Ann Arbor, Michigan
April 15, 2019

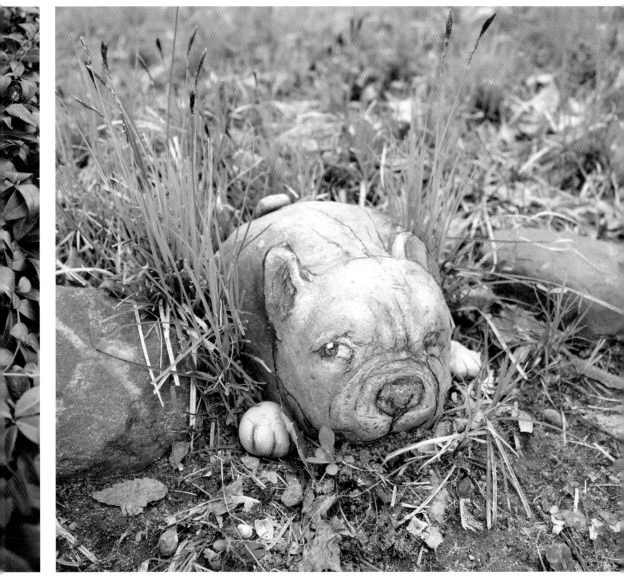

Paula can sleep anywhere so long as no one opens a bag of jerky.

Ann Arbor, Michigan
April 12, 2020

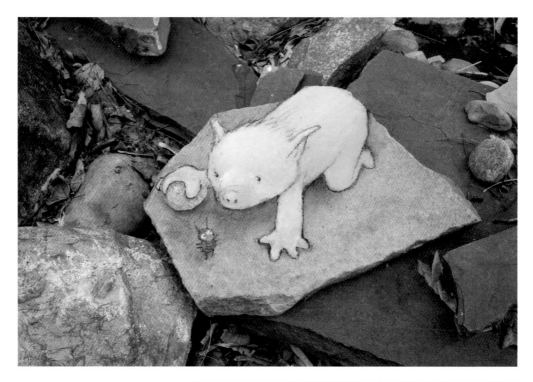

Nathan tests his theory that the happiest people are living under rocks.

Ann Arbor, Michigan
May 16, 2020

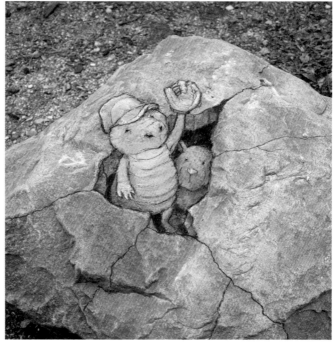

Steve takes his snowflake catching very seriously.

Ann Arbor, Michigan
January 14, 2020

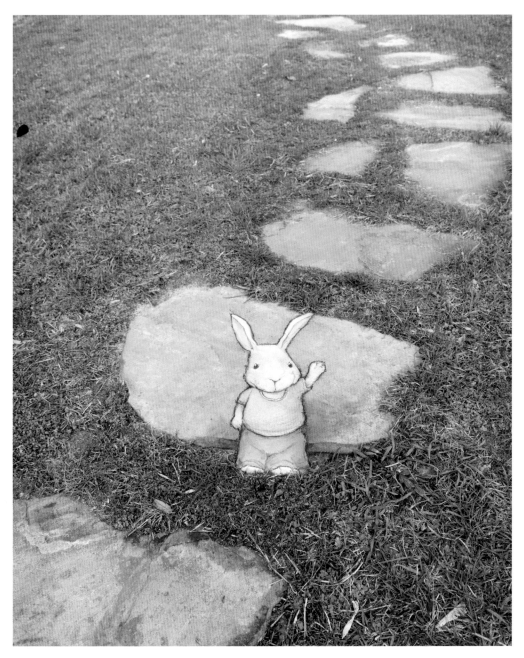

Hank said he gets asked that a lot this time of year,
but no, he's just a regular rabbit.

Ann Arbor, Michigan
April 1, 2020

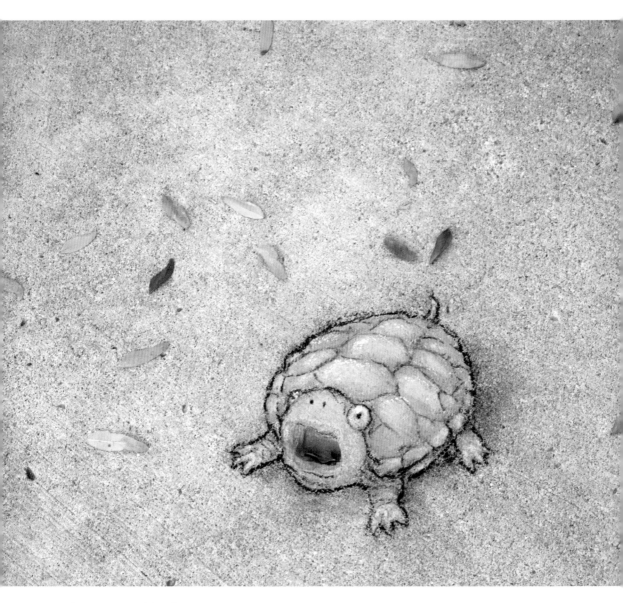

Gobsmacked by Autumn

Ann Arbor, Michigan
November 5, 2019

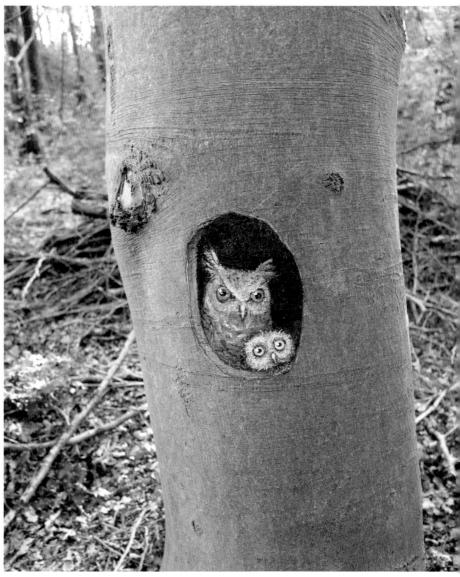

Posing for family portraits is always awkward
during the pinfeather stage.

De Wijk, Netherlands
August 30, 2019

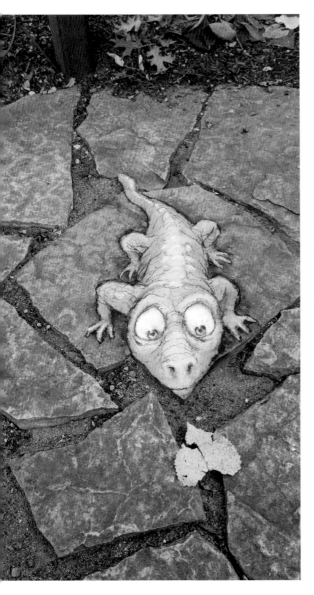

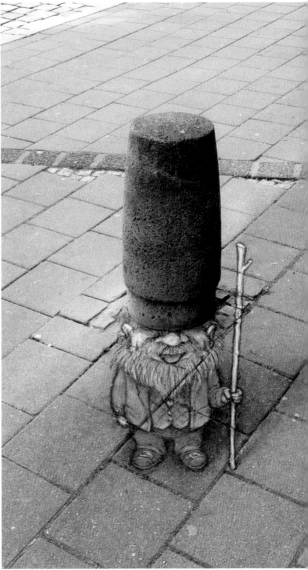

Love Is Where You Find It

Taylor, Michigan
August 7, 2019

Gustaf, shepherd of pedestrians, master of balancing heavy hats and silly faces, and capable of lying down while standing guard.

Fürth, Germany
May 27, 2019

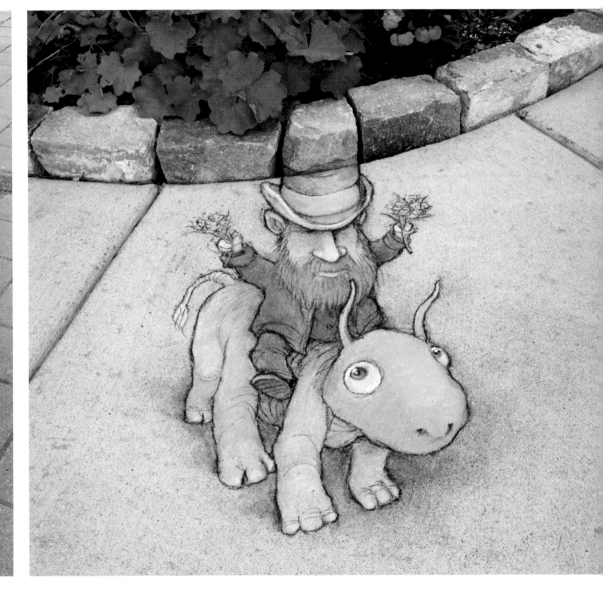

Hamish McFeeney always brings flowers to distract from his granite hat and improbable steed.

Taylor, Michigan
August 7, 2019

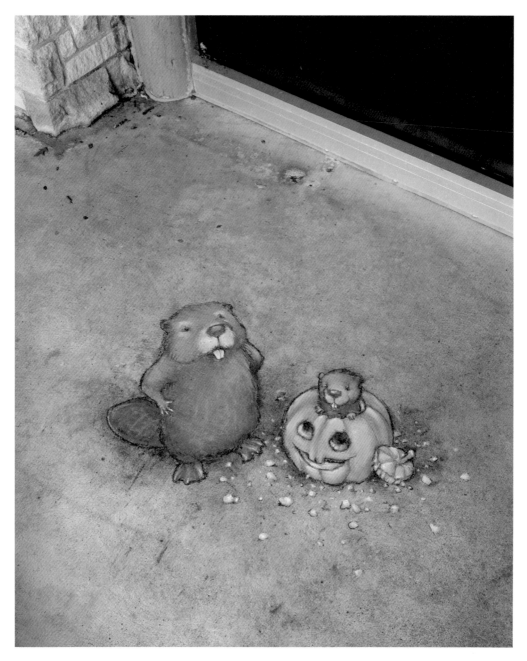

Father-and-son jack-o-lantern carving. Yours might be better,
but you probably used your hands.

Detroit, Michigan
October 26, 2019

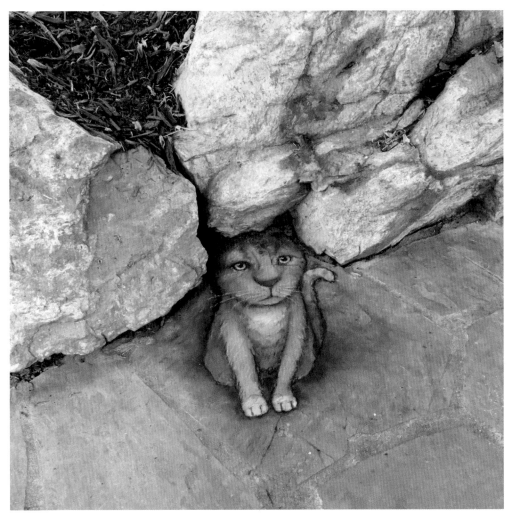

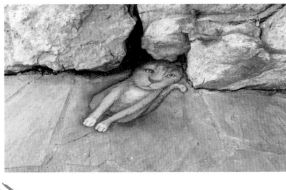

Cheshire-Eared Cat
Greenville, South Carolina
May 11, 2019

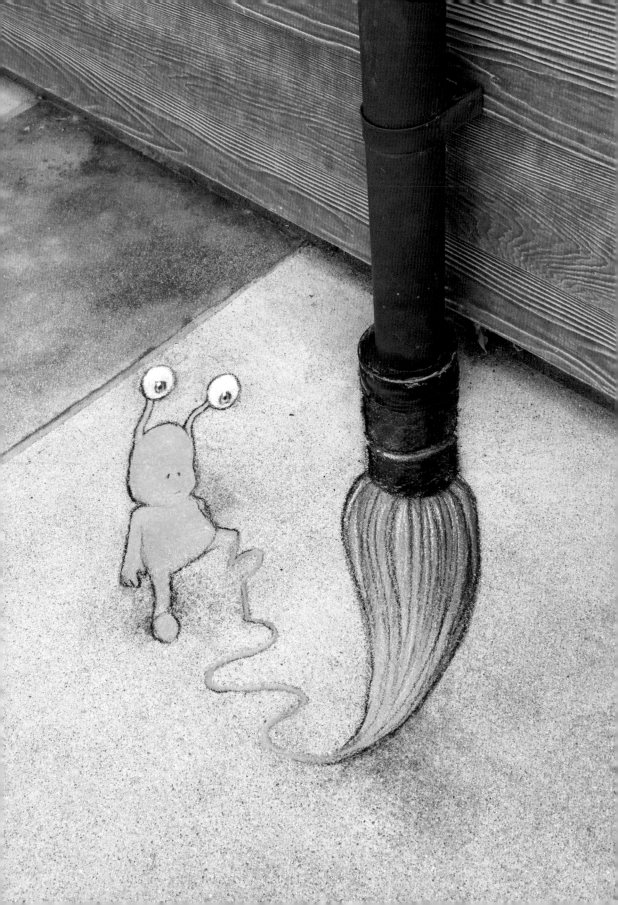

SLUGGO,

THE MONSTER WITH AN EYE FOR TROUBLE

Like Sluggo, I sometimes feel like my creator
got distracted before the job was done.

Laguna Beach, California
March 29, 2019

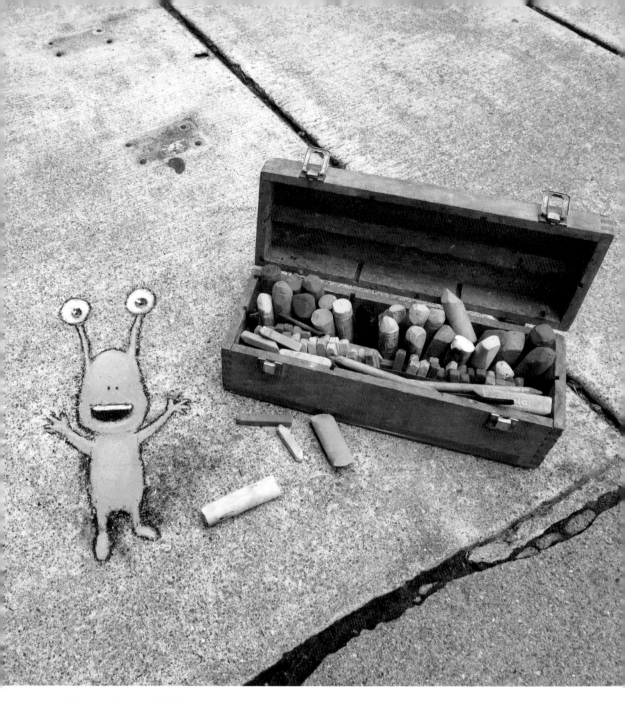

Sluggo Meets His Maker

Ann Arbor, Michigan
July 17, 2019

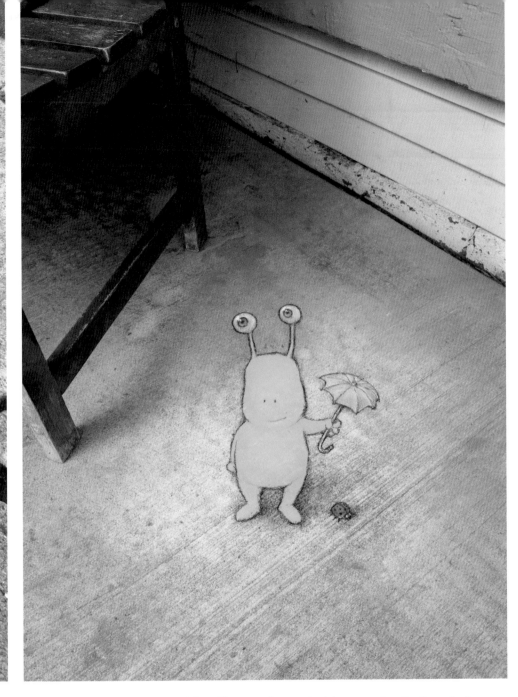

Among his many quaint habits, Sluggo always holds an umbrella for a lady.

Ann Arbor, Michigan
June 27, 2021

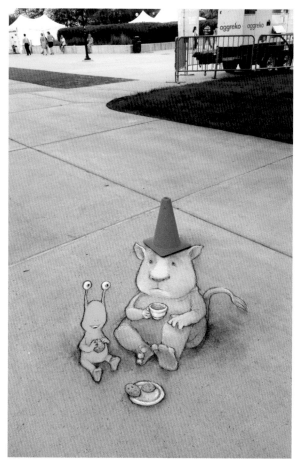

That feeling when a friend invites himself over to share cookies and keeps talking about how much better cookies are when you dunk them in tea and you know you have the only cup of tea and you really really hate finding cookie crumbs in it.

Ann Arbor, Michigan
June 29, 2019

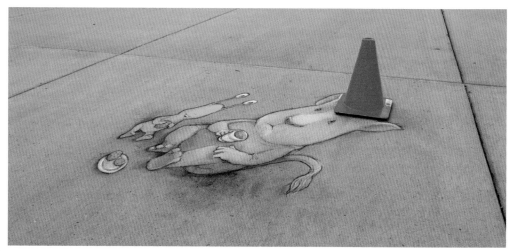

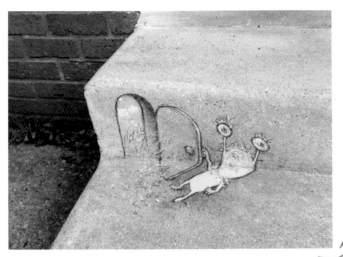

Sluggo finally found the door into springtime, but he overlooked the sign that said "knock gently."

Ann Arbor, Michigan
April 21, 2019

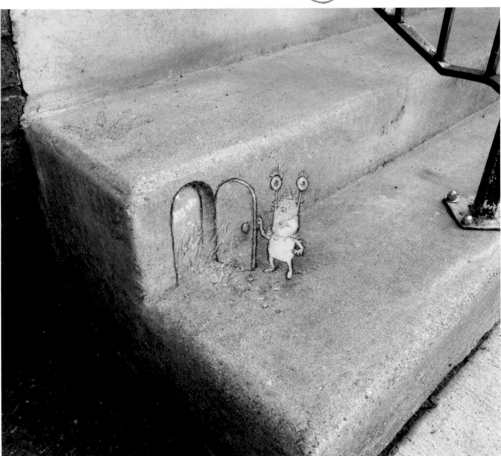

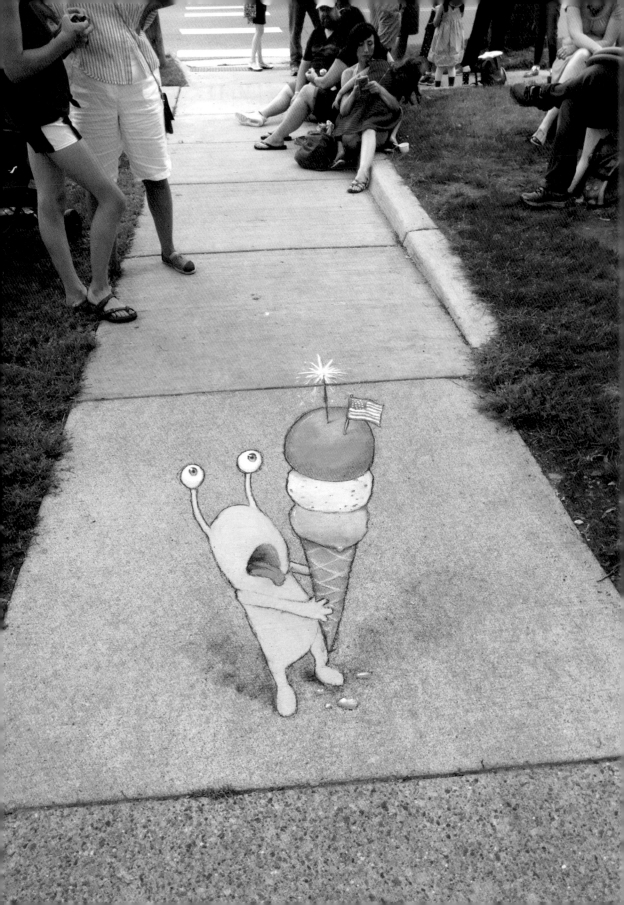

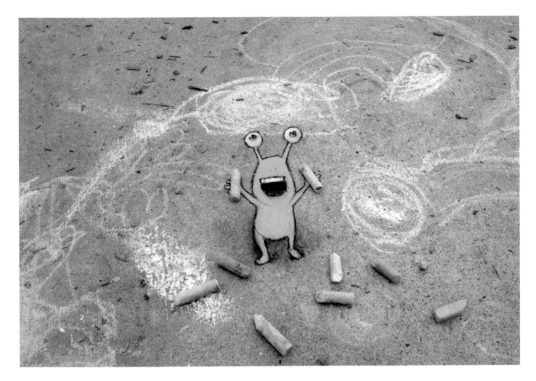

**Sluggo's Chalking Frenzy
(collaboration with artists unknown)**

*Ann Arbor, Michigan
March 3, 2020*

**Sluggo's summer ice cream tip: before
you get a triple, make sure your mouth
can physically reach the topmost scoop.**

*Ann Arbor, Michigan
July 4, 2019*

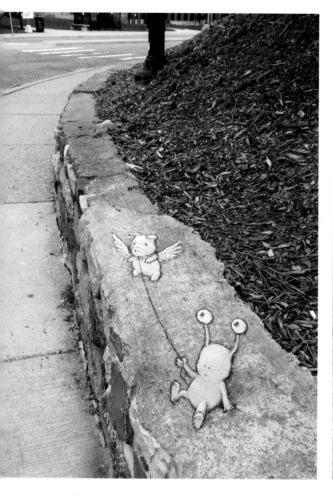

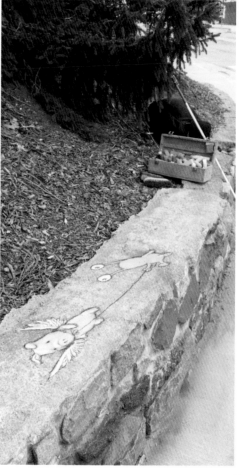

Sluggo and the Art of Porcine Aeronautics

Ann Arbor, Michigan
April 7, 2020

On the bright side, no one else was
downtown to hear Sluggo's one-man
performance of the *Burper of Seville*.

Ann Arbor, Michigan
April 7, 2020

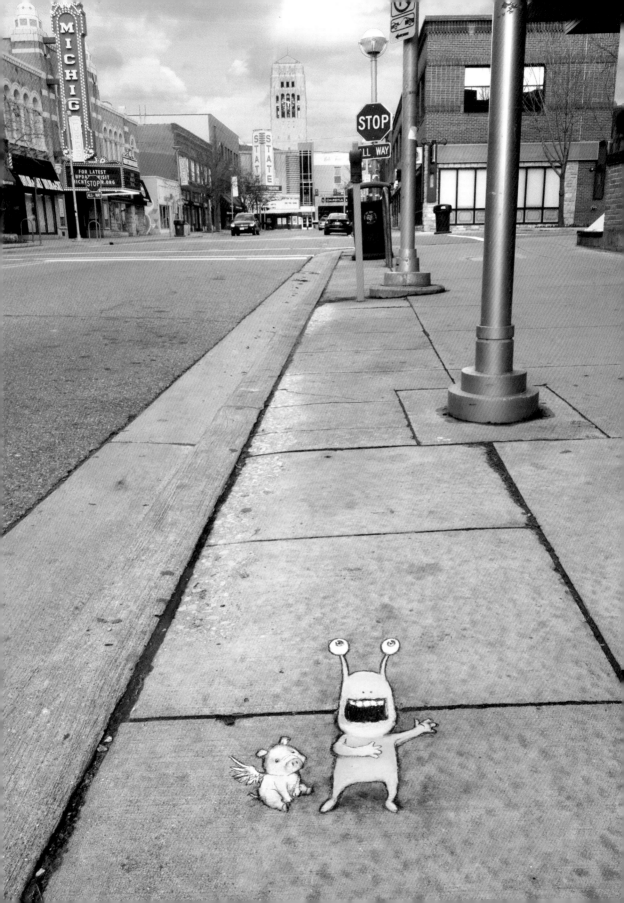

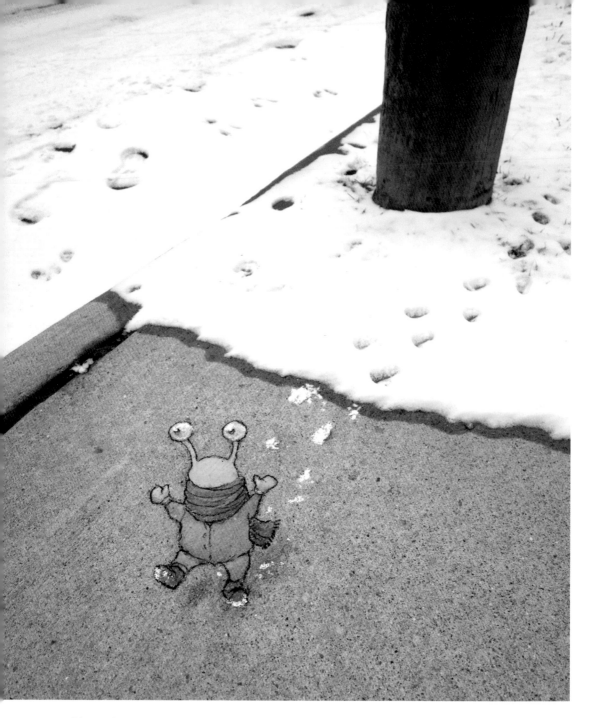

Sluggo's seasonal conundrum: by the time he's bundled up enough to go out and do things, the only things he can do are wave and waddle.

Ann Arbor, Michigan
December 27, 2020

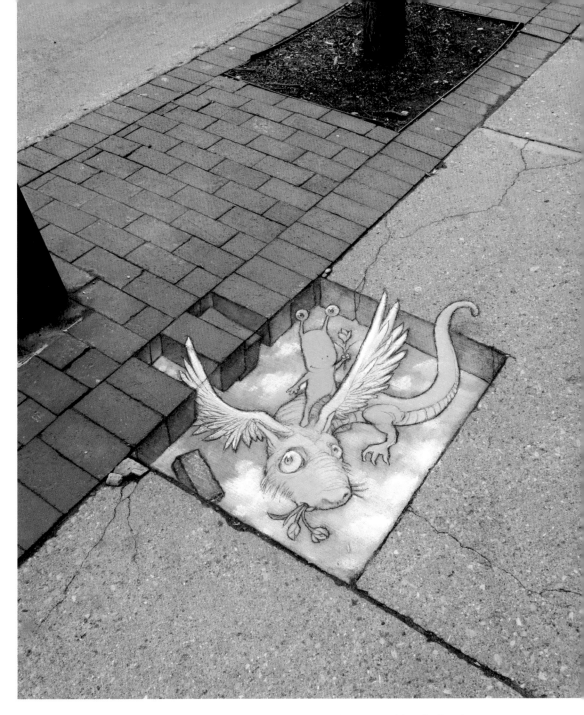

Having been left alone for one minute, Sluggo immediately befriended a dragon
and declared himself the King of Spring.

Ann Arbor, Michigan
March 24, 2020

Front Cover: Neil's "one cookie per day" rule has hit some technical snags. (p. 54)
Frontispiece: David Zinn, photo: © Misty Lyn Bergeron
p. 4: "On the bright side, no one else was downtown to hear Sluggo's one-man performance of the *Burper of Seville*." (p. 157)
pp. 20/21: Ernie "Goggles" Granger and his dog, Specs (p. 88)
Back Cover: David Zinn, photo © Fred Zinn; "Sluggo and the Art of Wearable Weeds" (p. 14)

2nd edition 2022
© Prestel Verlag, Munich · London · New York 2022
A member of Penguin Random House Verlagsgruppe GmbH
Neumarkter Strasse 28 · 81673 Munich

A CIP catalogue record for this book is available from the British Library.

Editorial direction: Anja Besserer
Copyediting: Martha Jay, London
Design and layout: Andreas Kalamala, ew print & medien, Würzburg
Production management: Andrea Cobré
Separations: Schnieber Graphik, Munich
Printing and binding: Alföldi AG, Debrecen
Typeface: Proxima Nova A
Paper: 150g Magnomatt FSC

MIX
Paper from responsible sources
FSC® C010328
www.fsc.org

Penguin Random House Verlagsgruppe FSC® N001967

Printed in Hungary

ISBN 978-3-7913-7936-4 (English edition)
ISBN 978-3-7913-7951-7 (German edition)

www.prestel.com

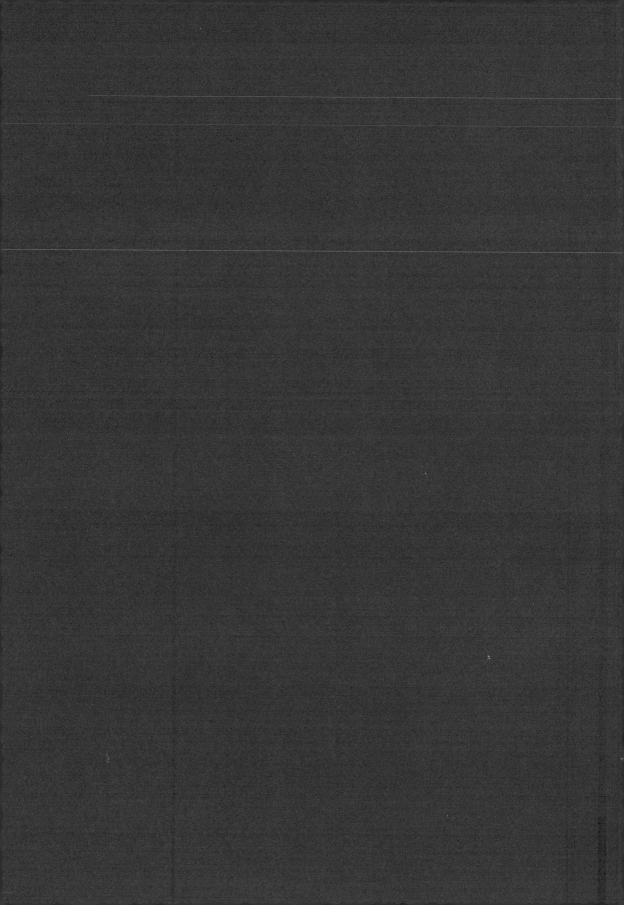